# Railroad Wars
## of
# New York State

TIMOTHY STARR

Published by The History Press
Charleston, SC 29403
www.historypress.net

Copyright © 2012 by Timothy Starr
All rights reserved

All images are from the author's collection unless otherwise noted.

First published 2012

Manufactured in the United States

ISBN 978.1.60949.727.9

Library of Congress Cataloging-in-Publication Data

Starr, Timothy, 1971-
Railroad wars of New York State / Timothy Starr.
p. cm.
Includes bibliographical references and index.
ISBN 978-1-60949-727-9
1. Railroads--New York (State)--History--19th century. 2. Railroads--Social aspects--New York (State)--History--19th century. 3. Railroads--Economic aspects--New York (State)--History--19th century. 4. Social conflict--New York (State)--History--19th century. 5. Businessmen--New York (State)--Biography. 6. Price fixing--New York (State)--History--19th century. 7. Strikes and lockouts--Railroads--New York (State)--History--19th century. 8. New York (State)--Economic conditions--19th century. 9. New York (State)--Social conditions--19th century. I. Title.
HE2771.N7S63 2012
385.09747'09034--dc23
2012026051

*Notice*: The information in this book is true and complete to the best of our knowledge. It is offered without guarantee on the part of the author or The History Press. The author and The History Press disclaim all liability in connection with the use of this book.

All rights reserved. No part of this book may be reproduced or transmitted in any form whatsoever without prior written permission from the publisher except in the case of brief quotations embodied in critical articles and reviews.

# Contents

| | |
|---|---:|
| Introduction | 5 |
| Canal Wars | 23 |
| Rate Wars | 41 |
| Hudson River Wars | 64 |
| The New York Central War | 79 |
| The Susquehanna War | 96 |
| The Great Erie War | 110 |
| Labor Wars | 131 |
| Timeline of Selected Events | 151 |
| Bibliography | 153 |
| Index | 157 |
| About the Author | 159 |

# Introduction

Here in the twenty-first century, when just a small part of the population travels by rail, it is hard to imagine the impact railroads had on all aspects of life during the 1800s. The spread of railroads to every corner of the country created a national economy for the first time, allowing millions of people to travel freely and businesses of all types to ship goods much more efficiently than ever before. Had railroad development not taken place, the country's great size would have been a liability rather than an asset, as villages and cities would have been forced to cluster around waterways and coastlines as thousands of miles of interior lands remained wild and unsettled. The nation would have remained almost defenseless, subject to internal conflict and foreign invasion, until the advent of internal engines more than a century after declaring independence.

Although a few primitive railroads were built elsewhere in the country first, New York State opened one of the earliest in 1832 and took the lead in constructing new ones. The presence of the Erie Canal across the middle of the state presented a powerful competitor, but the success of the first railroad—from Albany to Schenectady—proved to be an equally powerful incentive for others to put forth their own charters. Within a year, a veritable deluge of incorporations took place for rail lines between such population centers as Aurora and Buffalo, Brooklyn and Jamaica, Schoharie and Otsego, Ithaca and Geneva, Elmira and Williamsport and Rochester and Dansville.

Only a scant few of the three dozen railroads that were proposed in the months after the first railroad opened became a reality, but those that

# Introduction

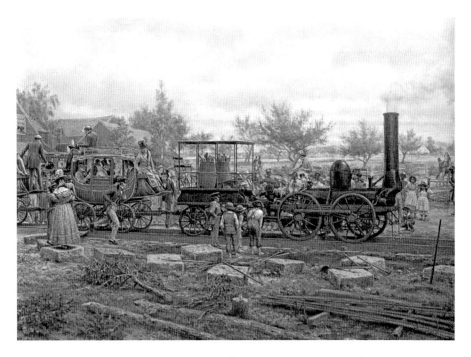

The first locomotive to operate in New York State excited the wonder of the surrounding countryside for months in 1832. Depicted is the Dewitt Clinton on its maiden run between Albany and Schenectady. *Library of Congress.*

did made up what would later become one of the nation's most important transportation systems. Throughout the 1830s and '40s, various small lines slowly spread throughout the Mohawk Valley, often closely paralleling the Erie Canal, until a nearly continuous connection between Albany and Buffalo was finally established. However, this new highway was practically useless as a means of mass transportation because the journey took two full days with seven changes of trains at great inconvenience. When the disparate roads were united in 1853, they constituted a powerful trunk line that created new opportunities for businessmen and farmers throughout the state and beyond.

Meanwhile, all of the stock of a new railroad from Saratoga Springs to Whitehall was subscribed by private investors as part of an effort to unite New York with Canada. It was exultantly declared that when the railroad was completed, passengers would be carried by steam power from New York to Quebec, using steamboats from New York to Albany, a train from Albany to Whitehall via Saratoga, another steamboat from Whitehall to St. Johns in Canada via Lake Champlain and a train from St. Johns to Quebec.

# Introduction

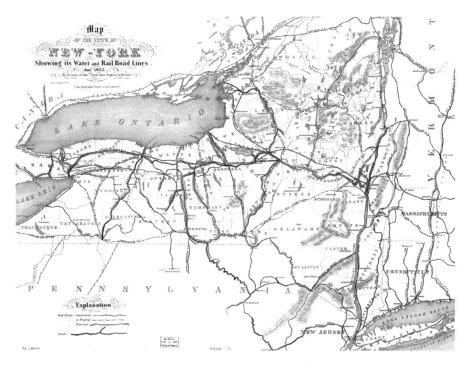

Within just twenty years of the opening of the Mohawk and Hudson Railroad, New York State was crisscrossed by dozens of railroads, including two trunk lines that linked the Atlantic Ocean with the western states. *New York State Archives*.

On a national level, the most important railroad construction before the Civil War was the east–west trunk lines. Seven such lines were constructed or formed from smaller roads: the Western and Atlanta in 1850; the New York and Erie in 1851; the Pennsylvania in 1852; the Baltimore and Ohio, the Canadian Grand Trunk and the New York Central in 1853; and the Virginia system in 1858. The western ends of these lines were still eastern cities like Buffalo and Pittsburgh, but agreements with other railroads gave them access to Chicago and the Far West. The most important trunk lines were the Pennsylvania, which controlled lines running west of Pittsburgh and thus obtained direct connections with Chicago, Cincinnati and St. Louis; the New York Central, which consolidated the Harlem and Hudson River Railroads at the east end and the Lake Shore and Michigan Southern at the west end, forming a continuous line from New York to Chicago; and the Erie, which was able to ship more freight than the New York Central despite being plagued by debilitating mismanagement.

# Introduction

As a consequence of unrest from the Civil War, railroad construction fell to 16,090 miles during the 1860s compared to 22,404 miles during the 1850s. However, the establishment of trunk lines and the consolidation of connecting railroads during the latter decade effectively tied the country together and enabled schedules to become synchronized on an unprecedented scale. The through freight lines that utilized cars belonging to other companies abolished once and for all the need for transshipment and "breaking freight" when crisscrossing the country.

By the end of the Civil War, nearly all passengers and the majority of freight went by rail. For the first time, stoves made in Albany and Troy were displayed in St. Louis next to stoves made in Detroit. Steamboats still remained competitive in carrying cheap, bulky products such as grain and timber. There were even a few river routes that could compete with railroads, most notably the People's Line of the Hudson River. But even these few vestiges of water transportation were under siege. The first all-rail shipments of grain from Chicago to Buffalo began in 1864, and within ten years they were surpassing the volume of grain carried by canals and rivers. Cities that served as rail hubs experienced unprecedented growth. Chicago, with railroads entering the city like spokes on a wheel, grew from less than 40,000 people in 1850 to 400,000 just twenty years later.

The railroad industry quickly grew to surpass all other industries combined. In an age when few factories, businesses or even banks were capitalized at more than $1 million, almost a dozen railroads had a capitalization of $10 million or more. The New York Central alone was capitalized at $25 million even before its merger with the Hudson River Railroad, equal to about one-quarter of all investments in U.S. manufacturing firms.

Contemporary critics were appalled at these numbers, especially in light of the fact that railroads do not create any products—they merely move products and people from point A to point B. However, in a large country with far-flung population centers, the net effect of the railroads was to create wealth by the tens of millions as businesses were able to distribute goods to a greater number of markets. In addition, railroads used a tremendous amount of resources, especially lumber, iron and coal, which in turn caused these industries to expand at a rapid rate. Many tens of thousands of people were employed directly by the railroads, and hundreds of thousands more were employed by industries that supplied them or were served by them.

A new breed of capitalist was born with the introduction of trunk lines that served multiple states and markets. The press dubbed them "railroad

# Introduction

kings" because they wielded the power to control commerce without the inconvenience of term limits that stymied even the most corrupt politicians. For a time, the state was able to control the railroads' fares and rates, but they soon became so powerful that legislators themselves were either bought or influenced enough to act in the best interests of the railroads rather than their own constituents. Even the judicial branch was not immune to influence, evidenced by judges issuing masses of competing injunctions at the behest of railroad executives who were carrying on wars against one another. Some of the most talented and effective lawyers were permanently attached to railroad companies with unprecedented retainers.

Thus the Erie Railway managers were able to selfishly manipulate company stock for their own profit for years, while the stock of the New York Central was "watered" with millions of new shares without a corresponding increase in infrastructure. From a competitive standpoint, railroads were allowed to purchase canals, rival railroads and industrial concerns in order to achieve a near monopoly in some markets. Hundreds of millions of dollars in profits accrued into the hands of the few while the public was often obliged to pay more for goods and travel than the actual investment in construction of the railroads would dictate.

Of the tens of thousands of people who invested in, built and worked on New York State railroads, four such "kings" stand out as historical figures of the great railroad wars that took place in the mid- to late 1800s. Of the four, two died with immense wealth while two died in relative poverty. Their names surface in several of the railroad wars, including those that involved the Erie, Harlem, Albany and Susquehanna, Hudson River and New York Central Railroads.

Cornelius Vanderbilt is perhaps the best known of these, and his name was attached to the New York Central system for many years after he passed away. He left a great fortune to his son William, as well as, more importantly, control of one of the largest and most profitable railroads in the country. Of the four "railroad kings," he was the only one to be remembered as a builder and operator of railroads, imparting real value to companies that were inefficient and failing. He made many enemies on his way to wealth and power, to be sure, but he was greatly respected at the time of his death in contrast to the other three titans of the railroad world, who were scorned as mere speculators that made their fortunes off the losses of others.

Cornelius Vanderbilt was born on Staten Island in 1794 to a well-off farmer who brought produce to market in his own sailboat. Cornelius was athletic and active as a young boy and could not bear to sit in a classroom, so his rudimentary education was obtained in the fields and on the bay.

# Introduction

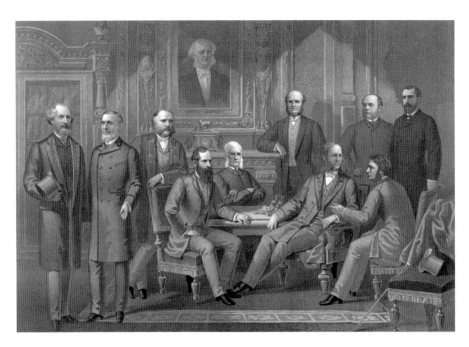

Four of the so-called kings of Wall Street who invested heavily in New York railroad stocks are depicted here: Cyrus Field (far left), Russell Sage (second from left), Jay Gould (seated, fourth from left) and William Vanderbilt (seated, fourth from right). Cornelius Vanderbilt's portrait gazes down on the gathering in this 1882 painting.

Through hard work and a thriftiness that would last his entire lifetime, he saved $500 and owned his own sailboat by the age of eighteen. After he married his second cousin, Sophia Johnson, he became the captain of a steamboat operating between New York and New Brunswick, New Jersey. As a result of his successes on the water, his family moved to New Brunswick and opened a hotel. By 1853, he was the owner of a profitable steamboat line that served all the ports of Long Island Sound and New York Harbor. During this time, he developed his skills as a ruthless competitor using two principal weapons that would serve him well later on: superior service and rate cutting. He drove weaker competitors to bankruptcy and threw all his resources against the strongest.

As is the case with many men of wealth, Vanderbilt was not a pioneer and, in fact, famously spurned new technology. When he was operating schooners, he belittled the steamboats that Robert Fulton was experimenting with on the Hudson River. After he switched to steamboats, he looked on the little locomotives chugging along primitive tracks with disgust. When a

## Introduction

friend attempted to interest him in the Harlem Railroad, Vanderbilt replied, "Bring me a steamboat and I can do something, but I won't have anything to do with your damned railroads!" As head of the New York Central, he met with a young George Westinghouse, who conceived a new braking system that would later be hailed as one of the industry's most important inventions. Vanderbilt sent him away claiming that he had no time for such nonsense. However, his business and management skills, along with boldness and acumen on the stock market, more than made up for his lack of vision.

When Vanderbilt first put a steamboat on the Hudson River, he met Daniel Drew, a man who was destined to be his foe in nearly every future business endeavor. The first contest between the two men ended with Vanderbilt claiming victory after a rate war forced Drew from the Hudson River. Vanderbilt then went up against the powerful Hudson River Association but was unable to dislodge the well-connected boat line. He finally struck a deal to leave the Hudson River for a hefty payment.

Vanderbilt accumulated more than $10 million with his steamboats, primarily by establishing a route to California during the gold rush, but he had an epiphany of sorts when he decided that the future of transportation was in railroading and not steamboats. He built the Staten Island Railroad and began withdrawing money from steamships to invest in rail lines. He purchased Harlem Railroad stock for $9 per share and became president of the company. Through effective management and cost-cutting measures, the stock was worth close to $100 per share within four years and paid dividends for the first time.

Although Vanderbilt was aged seventy when he first got into railroading, he managed to forge one of the few trunk lines in the country by taking over and merging the Hudson River and New York Central Railroads. He followed up that victory by becoming a majority owner of the Michigan Southern, Lake Shore and Canada Southern Railroads, which connected the New York Central at Buffalo with the thriving rail hub of Chicago. In the process of bridging New York and western states with a continuous rail connection under the control of one company, he increased his fortune from $10 million to $100 million in less than a decade. He died in 1877 with perhaps the largest fortune in the country and wisely left the bulk of his estate, including control of the New York Central and its subsidiaries, to his able son William in order to create a Vanderbilt dynasty.

Throughout his lifetime, Vanderbilt's chief nemesis was fellow steamboat operator and railroad capitalist Daniel Drew. Drew was roughly the same age as Vanderbilt, born on a small farm in Carmel, Putnam County, in

# Introduction

1797. He was forced to make his own way in the world at the age of fifteen when his father died. He took passage on board a Hudson River sloop to New York City and hired himself out as a substitute for a draft soldier. After his term in the army ended, he returned to Carmel to become a drover (cattle herder) at a time when the counties along the Hudson and Susquehanna Rivers supplied New York City with the bulk of its food. Finding success in this field, he soon established himself as a cattle dealer and made his headquarters at the Bull's Head Tavern in Manhattan. His first cattle drive consisted of two thousand heads purchased from villages in Ohio and Kentucky. It took him two months to cross the Alleghany Mountains, but when he reached New York, he was able to reap a substantial profit.

A few years later, Drew began his long career operating steamboats when he invested $1,000 in a share of the *Waterwitch*, a new steamboat that was built to transport passengers between New York and Peekskill. His aggressive and competitive personality was first highlighted when he used his profits to purchase three more steamboats and started a fare war with the Hudson River Company. He charged $1 per passenger and quickly forced the larger company to divide the business with him at the old rate of $3.

At this time, he met Cornelius Vanderbilt, who was operating steamboats in the same waters. Though they never became warm friends, they thought it best to collaborate rather than compete against each other. In 1850, they purchased a controlling interest in the Boston and Stonington Railroad and, using two steamboats of the latest design, engaged in transporting passengers, freight and U.S. mail between New York and Boston. Drew expanded his business into Lake Champlain, running five steamers between Whitehall and Rouses Point, but sold out at a profit to the Saratoga and Whitehall Railroad.

At about the time he entered the steamboat business, Drew was drawn to Wall Street and began speculating in stocks, showing an aptitude for reading the market and executing complex sales. He and two partners established a brokerage business and executed several profitable stock transactions that netted over $1 million. When his partners retired, he continued on his own and became interested in the Harlem and Erie Railroads.

It was while speculating in these two railroad companies that the most exciting and controversial period of his life began. Drew's preference was to make his profits while selling stock "short"—that is, betting that the stock would go down—while Vanderbilt always took the "long" position. These clashing ideas came to a head in the famous "Harlem Corner" when

## Introduction

Drew and members of New York City's Common Council attempted to profit on the stock after a rail extension franchise was defeated. Vanderbilt detected the scheme and purchased every share on the market, driving up the price and costing Drew dearly. Drew got some measure of revenge when Vanderbilt attempted to corner the stock of the Erie Railway and was foiled in the so-called Great Erie War.

Soon after the Erie battle ended, Drew was betrayed by Gould and Fisk, his former associates in the Erie executive committee, and forced off the board of directors. He continued to speculate in Erie and other railroad stocks with varying degrees of success, but he eventually lost all of his fortune and declared bankruptcy with $1 million of debts. No friends or family came to his aid, as he had garnered a widespread reputation for dishonesty and ruthlessness in his business dealings. There were several occasions during his stock speculating days that he admitted to turning on friends, associates and even fellow church members to make a quick profit. Often he would relate such mean-spirited transactions with much amusement in one breath and in another breath lament the fact that no one seemed to trust him. As one biographer put it, "He looked upon cards, the bottle, the theater, and dancing as things of the devil, but lying, duplicity, thievery, and greed were the passions of his life." When he passed away in 1879, few mourned his loss or remembered him with kind words.

Despite the widespread dislike and sometimes hatred of his countrymen, few disputed that Drew was one of the most formidable stock speculators in history. Perhaps his only superior was Jay Gould, who was for several years his business partner on the Erie Railway. The two, along with Jim Fisk, formed a triumvirate that proved to be a nearly unstoppable force, even to Vanderbilt. Gould was born in 1836, the son of a Delaware County dairyman. He soon grew tired of minding his father's cows and went to work for a blacksmith. Convinced that an education was the only way he could succeed in life, he studied books for three hours every day before work, beginning at three o'clock in the morning. Once he attained a basic understanding of mathematics, he went to work for an engineer who was making a map of Ulster County. Later he went into the mapmaking business for himself and cleared $5,000 one summer drawing maps of Albany and Delaware Counties. A few years later, he purchased a tannery in Ulster County and opened an office in Manhattan. While making a respectable living as a tanner in 1860, he began to study railroads, then in a depressed condition. Hundreds of miles of rails lay unused, passenger cars and locomotives rusted in abandoned yards and stocks were at an all-time low.

## Introduction

However, he believed that the railroads would come back to life, especially in the event of a civil war.

Gould found a neglected railroad running from Troy, New York, to Rutland, Vermont, that was selling first mortgage bonds for ten cents on the dollar. Upon purchasing these, he became president, and despite having no experience in running a railroad, he assumed active control as superintendent. To raise capital, he set the stock par value at $120. He then purchased stock in the Cleveland and Pittsburg Railroad and watched as the share price increased by $50. These initial successes brought him some modest riches, as well as influential friends who would help him in the future.

Recognizing that he could make many hundreds of times more money in the railroad business than in the leather business, Gould sold his tannery and began speculating in Erie Railway stock. He struck up an acquaintance with Jim Fisk and Daniel Drew and soon became a part of the executive committee just a short time before the Great Erie War broke out between Drew and Vanderbilt. The five years he spent on the Erie Board of Directors were among his most profitable, raking in millions of dollars by shrewdly placing bets on whether Erie stock would go up or down and then influencing events to ensure his success. When he was finally forced from the Erie Railway by a group of English investors, it was determined that he had converted at least $12 million of company funds to his own use.

Perhaps his boldest scheme was an attempt to corner the gold market. There was only $15 million worth of gold in circulation, so anyone with a large fortune could in theory manipulate the supply and earn millions as the price fluctuated. The great roadblock to such a scheme was the fact that the United States government held almost $100 million in gold reserves and could flood the market with it if there was a run on gold prices. To improve his chances for a successful gold corner, Gould bribed President Grant's brother-in-law, Abel Corbin, to counsel him on U.S. gold policy. Through Corbin's false promises and misunderstandings, Gould believed that he had the president's full cooperation and began buying millions of dollars worth of gold.

Gould's scheme came to a head on September 24, 1869, which would forever be known as Black Friday. The demand for gold reached a fever pitch, sending the stock market crashing. However, just as it seemed that the economy would suffer a mortal blow, the president announced that he was releasing $4 million worth of gold from the treasury, which had the effect of immediately deflating the market price. Gould later tried to explain away his outrageous plan when he testified that it was all done for the Erie Railway—if he could

## Introduction

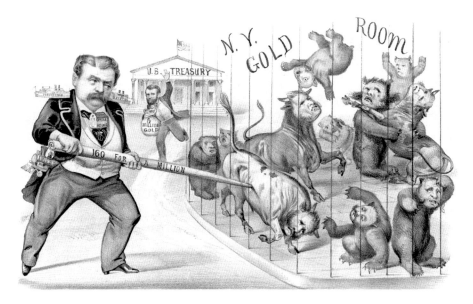

One of Jay Gould's many outrages was his attempt to corner the gold market in 1869, forcing President Ulysses Grant to take action to avoid an economic collapse. His front man, Jim Fisk, is seen poking the "bulls" and the "bears" of the stock market. *Library of Congress.*

increase the price of gold, the price of wheat would increase to such an extent that farmers would sell their annual crop and ship it via railroad before the fall "package goods" business arrived.

Almost one thousand investors lost everything they had, including Jim Fisk, who invested millions at Gould's behest. Gould hedged his bets and came away from the fiasco with the bulk of his fortune intact. Leaving the Erie behind, he speculated in the Union Pacific Railroad and eventually turned a profit of some $40 million. He similarly invested in the Missouri Pacific, the Wabash and the elevated railroads of Manhattan. Later, he engineered a stock market campaign against the Western Union Telegraph Company that almost sent it into bankruptcy, allowing him to acquire it for a fraction of its real value. When he died of tuberculosis in 1892 at the relatively young age of fifty-five, he left a $72 million estate to his family.

The third part of the Erie triumvirate was Jim Fisk, who often acted as the Erie Railway's bold and flamboyant front man while Gould and Drew worked behind the scenes. Fisk was born in Pownal, Vermont, in 1835, and at an early age, he joined the circus as a tent hand and assistant doorkeeper. After seven years with the circus, he returned home to Vermont and took

# Introduction

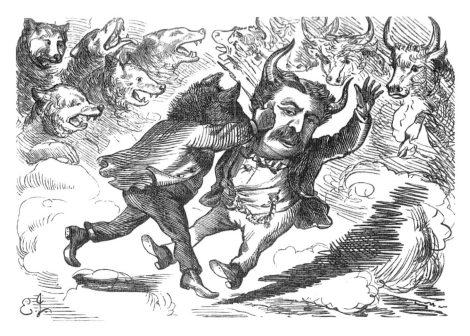

The so-called robber barons were often the subject of scorn in national newspapers, such as this cartoon of Jim Fisk in the aftermath of Black Friday.

up his father's peddling business. Displaying a knack for self-promotion, he put together a four-horse team complete with a decorated wagon that was the marvel of the country road. He plied the states of New England with dry goods until a Boston firm invested in his company and hired him as a salesman. Although he was later made a partner, the firm learned to distrust him, and he was bought out for $250,000.

After squandering most of his money in Boston, he came to New York and opened a brokerage business. This venture was not very successful, but one day on a whim, he approached Daniel Drew at the Erie Railway office and offered to handle a sale of stock for him. He carried out the transaction so successfully that Drew set up the brokerage house of Fisk, Belden and Company to handle more of his stock dealings. While at the Erie, Fisk met Jay Gould, and the two formed an unlikely but long-lived partnership. While Gould was reserved and shied away from publicity, Fisk was outgoing to the point of obnoxiousness, yet the pair hit it off and made a formidable team. Because Fisk often acted as the Erie ambassador, he endured most of the fallout of the gold corner of 1869, even though he lost heavily.

# Introduction

Fisk decided at one point that the Erie Railway would benefit from control of New York City's oil business. He entered into a partnership with Edward Stokes, who restarted the defunct Brooklyn Oil Refinery in 1865. The arrangement between the refinery and the Erie Railway for shipping oil promised to be a lucrative one had it not been for the presence of Helen Josephine Mansfield. Upon meeting her at an event, Fisk became infatuated and set her up in an opulent house on Twenty-third Street, despite the fact that he was already married. Stokes and Mansfield began an intimate relationship that naturally led to a series of escalating arguments between Stokes and Fisk. The love triangle ended in 1872 when Stokes fatally shot Fisk on the main stairway of the Broadway Central Hotel.

The actions of these four men would have long-range consequences on New York State railroads. The wars fought among the men who controlled them nearly monopolized the nation's attention throughout the so-called Gilded Age. Even one of the most dramatic events in the history of politics, the impeachment proceedings of President Andrew Johnson, was relegated to the second page of many newspapers during the Susquehanna War of 1869. The ongoing Erie wars and the actions of the Vanderbilt family similarly dominated national headlines for years on end.

As was often the case with new technologies, the initial innovators and inventors who put the infrastructure in place and took all the financial risks were then pushed aside by wealthy investors once success was on the horizon. This was especially true of the railroads.

The era of the stock speculators and robber barons began with the state's first railroad. The Mohawk and Hudson was fearlessly championed by a dreamer from Duanesburg named George Featherstonhaugh, a gentleman farmer who had hopes of building a railroad ever since he saw his first one on a trip to England. He overcame Erie Canal interests in the legislature to get a railroad chartered in 1826. However, the charter stipulated that the railroad could not carry freight, making it difficult for Featherstonhaugh to sell stock. The share price declined, and the project remained on hold as he tried to reach agreement with the legislature on changes to the charter. A group of speculators from New York City purchased the stock at depressed prices, and using various lobbying efforts such as "gifts" of stock, the members were able to persuade the legislature to lift the ban on carrying freight. The price of the stock went up immediately, and the speculators sold out for a profit. By then, Featherstonhaugh had been forced from the board of the company he had started.

A half century later, the speculators were still at it, this time targeting the elevated railroads of Manhattan. Rather than attempt to purchase

# Introduction

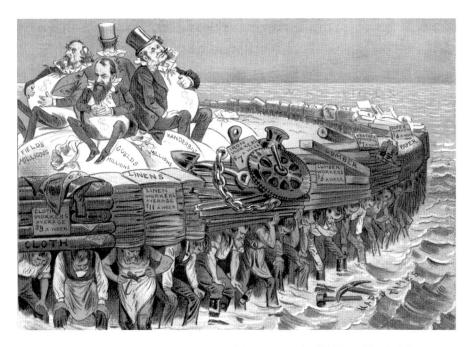

Cyrus Field, Russell Sage and Jay Gould (all sitting to the left of William Vanderbilt, center) took over the elevated railroad system of Manhattan and thus held a monopoly on the city's public transportation. This led to the usual abuses of power, to the detriment of workers and travelers alike. *Library of Congress.*

the two existing elevated railroads outright, which would be costly and controversial, Jay Gould and his friend Russell Sage hit on a plan to use a corporation called the Manhattan Company to gain control. If they could successfully wage a "bear" campaign against the Manhattan, they could buy its stock at low prices and then control the two railroads through a lease arrangement. Gould's use of his newspaper, the *New York World*, to batter down the price of the Manhattan Company's stock was considered by some to be unprecedented in the history of journalism. Throughout the months of May, June, July, August and September, the attacks made on the company were so persistent and uniformly negative that they had the almost inevitable effect of scaring hundreds of investors into selling their stock.

By October, the stock price was just $16 per share, down more than 70 percent from its high. Gould, Sage and several associates made their move and purchased seventy thousand shares of stock for $1.1 million. The *World* quietly noted, "Wall Street was surprised yesterday to learn that on closing the books of the Manhattan Company it was discovered that Mr. Jay Gould

INTRODUCTION

The elevated railroads of Manhattan were targeted by Jay Gould and several business associates in the 1880s. Pictured is the New York Elevated Railway in the Bowery neighborhood. *Library of Congress.*

and his associates owned one-half of the stock, the total amount which is 130,000 shares." The independent *New York Times* was not so forgiving, announcing that "[t]here is no more disgraceful chapter in the history of stock jobbing than that which records the operations of Jay Gould, Russell Sage, and Cyrus Field and their associates in securing control of the elevated railroads in this City." The usual stock watering operations took place in the months that followed, creating tens of millions of dollars in bogus capital, with little new construction to justify it.

Many of the outrageous antics conducted by New York's "robber barons" were completely legal in an age when few regulations existed. The state court system itself was dysfunctional. Despite its name, the Supreme Court was actually a lower court rather than one of last resort as it is today. Each of the eight judicial districts contained four judges that were elected every fourteen years. These highly politicized and corruptible judges had authority extending throughout the state that sometimes resulted in an almost comical flurry of conflicting judgments. They also had the power to unilaterally issue

# Introduction

injunctions and appoint receivers that could seize control of a railroad with little warning. Manhattan attorney George Templeton Strong lamented that "no bank or merchant is sure that some person calling himself a 'receiver' may not march into his counting room at any moment, demand possession of all his assets, and when the order for a receiver is vacated a week afterwards, claim $100,000 or so as his 'allowance' for his services."

While pliant judges were used to gain control of railroads, the practice of "watering stock" allowed the new owners to instantly and effortlessly profit by them. When the management of a company issued more stock than the company was worth, or for new construction work that was never carried out, it was commonly referred to as being watered, since the additional shares did not represent real value. The only effect was that the railroad was forced to pay dividends from that moment forward on the original stock and the watered stock. The practice began when the stocks of the original small railroads that made up the New York Central were increased by $9 million after the consolidation. Though various property improvements increased the value of the stock over the next fifteen years, Vanderbilt increased the capitalization of the combined New York Central and Hudson River Railroad to $90 million. A legislative committee investigation calculated that 36 percent of it was "water." The stock watering of Gould and Drew at the Erie Railway was even more obscene. It was estimated that the railroad, which was capitalized at $155 million, could be completely replaced for $65 million.

The railroad wars lasted from 1830, when the first small lines were built to compete with the Erie Canal, to the turn of the century, when railroad systems had become so large and prosperous that they could no longer be managed by one person or subjected to wild stock speculations. This was an era when, for good and bad, economic society was truly free. There were few governmental regulations, no antitrust laws and no self-rule in business. The New York legislators of the late 1860s were notoriously corrupt and accepted bribes with little secrecy or remorse. Railroad unions were not yet strong enough to influence the thoughts of the capitalists. The Industrial Revolution was imparting great changes in the way goods were manufactured, but the manufacturing sector itself was still dominated by small operators with fewer than five employees. Farms and mercantile businesses were likewise small and had not yet developed cartels, trade associations or lobbyist groups.

Several states attempted to regulate railroads beginning in the 1870s, but the Supreme Court ruled these state laws unconstitutional because they violated the commerce clause of the constitution. This forced Congress to

act. The public had grown weary of watching in horror as railroad magnates dictated rates that seemed to favor some and discriminate against others or enter into "pools" and trusts that fixed rates higher than a free market would have supported. Therefore, in 1887, the first federal law designed to regulate private industry was passed by Congress and signed by President Grover Cleveland—the Interstate Commerce Act. It attempted to limit rate fluctuations and price gouging by mandating that all rates be made public and ruling that rebates and discrimination were illegal.

Part of the act created the Interstate Commerce Commission (ICC) to hear complaints against the railroads and issue "cease and desist" orders as needed. One serious limit to its powers was that it could only regulate railroads that crossed state lines. The Elkins Act gave it the power to impose heavy fines on railroads that offered rebates, while the Hepburn Act went a step further and gave the ICC the power to set maximum freight charges. Railroad companies were forced to use standardized bookkeeping and remit financial statements to the ICC annually. Many historians contend that the Hepburn Act led to the decline of the railroad industry as both steam and electric railroads had to struggle with rising costs while being unable to raise rates without permission from the slow-moving government entity.

The "wars" fought by the railroads beginning with their inception were constant and varied. Those included in the following pages are meant to portray examples of the most famous wars rather than a tedious rendition of every railroad battle ever fought in New York State. A broad spectrum was intentionally chosen that hopefully imparts an informative history of railroading in general, as well as of the battles that took place on and around the rails more than a century ago.

# Canal Wars

The Mohawk Valley of New York State played an important role in the development of the country. The valley's narrow ribbon of land, rarely more than twenty miles in width, for many years contained from 80 to 90 percent of the population of the state and the vast majority of its wealth. Not only did it offer a trading route among its most important industrial cities, but it was also the primary gateway to the western part of the country via the Great Lakes. Any route to the south of this path had to contend with the Appalachian Mountains, which would not be successfully surmounted until the age of the automobile.

The advantages of travel through the Mohawk Valley were first appreciated by Native Americans and were an important factor in the rise of the League of Five Nations. Traveling swiftly in their bark canoes, the warriors of these tribes extended their influence for hundreds of miles beyond the territory they controlled.

The first European settlers in New York colonized the banks of both the Hudson and Mohawk Valleys, foreshadowing the route that would eventually become the chief waterway and railroad system of the country. Only after the American Revolution did the western part of the state become populated enough to warrant a canal to link the Atlantic Ocean and the Great Lakes. The first serious project of this sort was presented in 1785, citing the Mohawk River as the only gap in the Appalachian chain. The population of the state did not exceed 500,000, but with a growing number of people heading west to find new farmland, the first small step of a much greater effort was proposed that would connect the Mohawk River with Wood Creek at Rome. However, the project failed due to a lack of subscriptions.

A short time later, two private enterprises were incorporated through acts of the legislature. The Western Inland Lock Navigation Company proposed to construct a canal from the Hudson River to Lake Ontario, while the Northern Inland Lock Navigation Company would link the Hudson with Lake Champlain. The work of the former consisted of a canal two miles in length connecting the Mohawk with Wood Creek and another canal at German Flats, along with a small series of locks at Little Falls.

Despite the seemingly obvious advantages of bridging the gaps of the Mohawk River from Albany to Buffalo, there were again not enough private subscriptions to begin work. Ruling that the canal network would serve a vital purpose to commerce, New York State became a large shareholder of the company. The War of 1812 delayed any further action, but Governor Dewitt Clinton revived the idea a few years later and charged a special commission with the task of outlining a canal route and its specifications. The commission reported to the legislature with the recommendation to build a canal four feet deep, twenty-eight feet wide at the bottom and forty feet wide at the surface and locks with dimensions of ninety feet long and twelve feet wide. By this time, it was determined that private subscriptions of any size would not be forthcoming. Attempts to even obtain a small amount of federal aid failed, so the state reluctantly undertook the entire cost of construction after much debate.

The conditions under which the canal was built are difficult to imagine. There were no contractors capable of handling large public projects, excavating machines had not been invented, the countryside was sparsely populated, transportation and distribution was slow and difficult, few engineers had the proper experience and those who did undertake the contracts had little capital to fund their activities. Therefore, the work was divided into small sections, and advances of funds were handed out by the state to cover labor costs. Special tools were invented to aid workers in their toils, while waterproof cement was perfected by engineer Canvass White.

Work on the middle section of the canal went so well that the legislature authorized work to begin on the western and eastern sections. The Mohawk River was connected to the canal by a temporary lock so that navigation was possible from Schenectady to the Cayuga and Seneca Lakes. By the time all three of the sections were completed and linked together, the state had spent $7 million, about $1 million more than the original estimates.

On October 26, 1825, a statewide celebration took place to commemorate the grand opening. Governor Dewitt Clinton boarded one of a fleet of five ships to make the journey from Buffalo to Schenectady. Cannons were set

up within hearing distance for the entire length of the canal so that when the boats set off, the cannons would fire and announce the fact to revelers up and down the Mohawk Valley. It took an hour and a half for the cannon volley to travel from Buffalo to New York City.

Despite criticism that the narrow waterway would never be profitable (derisively called by some "Clinton's Ditch"), the Erie was declared an immediate success and became the most important transportation system in the country. New York City immediately became the dominant seaport on the Atlantic, while Philadelphia was relegated to second place. Agricultural products that previously had been floated down the Susquehanna River to Baltimore were sent directly over the Hudson River route. Branch canals around New York State served as feeders and created flourishing towns along the junction points.

Other states tried to emulate the Erie's success. A waterway was constructed from Philadelphia to the Ohio River at Pittsburgh, but the higher elevations resulted in a cost double that of the Erie and the need for many more time-consuming locks. Merchants in Baltimore poured funds into a canal across Maryland toward the Appalachians but were unable to reach the Ohio River on the other side. The people of Richmond began construction on the James River Canal but were also stymied by the mountain range and abandoned the project.

The economic benefits of the canal became readily apparent. Before its opening, Genesee Valley wheat took twenty days to reach Albany by wagon and cost $100 per ton. Once the canal opened, a ton of wheat could be moved all the way to New York City in ten days and cost only $5. Included in the tonnage of goods shipped east in its opening year were 560,000 bushels of wheat, 220,000 bushels of flour, 435,000 gallons of whiskey and 32 million board feet of lumber. More than ten thousand boats paid the state $300,000 in tolls that year. It is easy to see why a threat from another transportation system would be met with at least some resistance from legislators eager to protect this important source of income.

Hauling freight on the canals was literally a way of life for thousands of people, so it is not surprising that many of them fervently opposed the construction of railroad lines anywhere near canal routes. The vast majority of the "canalers" worked, ate and slept on their boats for the entire season. While most worked alone or with one or two helpers (in addition to the requisite mule to pull the boat along), some were accompanied by their entire families. Thousands of children grew up in little boat cabins no more than ten feet wide and learned the ways of the world by visiting the hamlets and

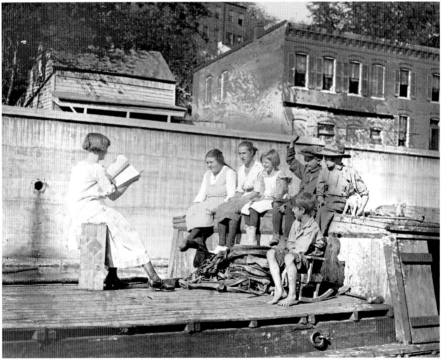

Some boat owners' families accompanied them on their canal trips from New York City to the Great Lakes. "Canaling" soon became a way of life for more than half a century. *Library of Congress.*

cities along the canal. Because the speed of the boats was so slow and the mileage involved was so great, a typical working season on the Erie Canal consisted of six round trips from the Atlantic Ocean to Buffalo. A large number of boats were quartered at the Atlantic Basin near Brooklyn during the winter while their owners spent a few leisurely months at home. Many single men remained with their boats year round and therefore spent the winter either tied up in New York City or hauling freight in warmer climates.

Long before the Erie Canal began operations, several forward-thinking individuals were touting the advantages of railroads over waterways. The world's first railroads in England were reportedly successful in bringing coal from the northeast corner of the country to the docks. News that an engineer by the name of Stephenson had invented a steam wagon that could run on rails generated even more interest. The first steam-driven railroad was built from Stockton to Darlington to carry both passengers and freight. However, no movement was seriously undertaken to incorporate a railroad company while the Erie Canal was still being built, as all of the state's attentions and efforts were being poured into that endeavor.

Almost as soon as the Erie Canal was complete, George Featherstonhaugh and Stephen van Rensselaer, two prominent men from the Capital District, managed to bring a bill before the legislature to incorporate the Mohawk and Hudson Railroad Company. Its purpose was to build a railroad between the Hudson River at Albany and the Mohawk River at Schenectady. There was great debate in the state assembly, as many were opposed to approving a new transportation system so soon after millions of dollars of public money had been spent on what was considered to be one of mankind's most successful engineering projects.

Martin van Buren originally opposed the creation of the Erie Canal when he was a state legislator but switched sides at a crucial moment. As New York State governor, he continued his support of the Erie Canal as groups began applying for railroad charters. In a letter to President Andrew Jackson, Van Buren urged federal support to preserve the canals against the encroachment of the railroads. Underestimating the job creation potential of the railroads, he warned that they were about to cause the widespread unemployment of "captains, cooks, drivers, hostlers, repairmen, and lock tenders, not to mention farmers supplying hay for horses." The canal was also vital to the defense of the nation in case of another war with England, since the Erie "would be the only means by which we could ever move the supplies so vital to waging modern war." Worst of all, he contended that the railroad carriages were designed to be pulled at the "enormous" speed of fifteen

miles per hour by engines that "endanger the life and limb of passengers and frighten our women and children…The Almighty certainly never intended that people should travel at such breakneck speed."

The notion of a steam-powered railroad was sometimes opposed by the general public as well. In one well-publicized letter, a concerned citizen wrote, "Canals, sir, are God's own highway, operating on the soft bosom of the fluid that comes straight from heaven. The railroad stems from hell; it is the devil's own invention, compounded of fire, smoke, soot, and dirt, spreading its infernal poison throughout the fair countryside." The writer went on to warn of burned houses, despoiled land, a ruined landscape and "a desert where only buzzards shall wing their loathsome way to feed upon the carrion accomplished by the iron monster of the locomotive engine." In the New York and Erie Railroad's first annual report, it was stated that when a feasibility study for constructing the new line was presented to the legislature, a "combination of local interests, singularly violent in character, was arrayed to defeat the enterprise."

Featherstonhaugh persisted in lobbying for the railroad project throughout the debate. In a letter to the mayor of Albany, he pointed out that transportation of freight and passengers by packets between Albany and Schenectady often took one or two days by canal due to the slow speed of the boats and the twenty locks that were needed to overcome the change in elevation. The same trip by railroad could be accomplished in less than three hours at the same cost. Furthermore, the railroad would continue to operate during the winter months while the canal was frozen. The trip by canal was so despised that many chose to take a stagecoach to Schenectady.

The Speaker of the House, Clarkson Crolius, finally sided with the railroad project. He believed, somewhat incorrectly, that while passengers and baggage could be carried by railroad, heavy freight would continue to be transported by the canal, and state revenues from that source would not be diminished. In the end, he wanted to see the experiment of a railroad attempted in this country, especially because it was a private company that was not requesting public funding.

The bill passed the assembly on March 27, 1826, incorporating the company with a capital of $300,000 for a duration of fifty years. Featherstonhaugh and Van Rensselaer were given six years to construct the railroad, after which the franchise would be forfeited. A few months later, stock subscriptions were opened to the public to finance the endeavor.

However, canal interests held up construction for several years as details of railroad operation were negotiated. The terms of the original charter were harsh. The directors and stockholders were held personally liable for

# Canal Wars

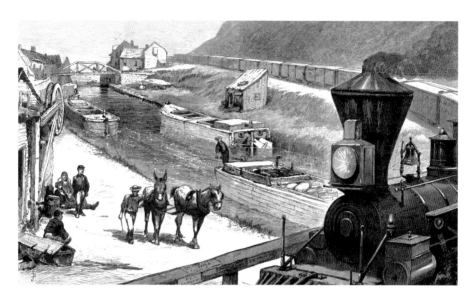

By 1840, there were several railroads that paralleled the Erie Canal, creating the first real competition since it opened in 1825.

the company's debts, which was a direct contradiction to the very idea of a corporation. The state reserved the right to appropriate the railroad at any time within five years, so that any potential success could suddenly be swept away if the government decided it wanted to assume control. Two years later, the charter was amended to remove the personal liability clause and add the stipulation that if the state decided to take over the railroad, it would have to pay 14 percent interest on all expenditures so that investors would at least make a return on their investment. After these changes were approved, stock subscriptions picked up and construction commenced.

Once the railroad began operation, many packet boat men hailed the Mohawk and Hudson as a great help to their business. Between Albany and Schenectady was a lengthy bend in the canal that the railroad bypassed. This encouraged new travelers to ride the train to Schenectady and board a canalboat for the rest of the trip to Utica and beyond. Meanwhile, freight continued to be carried almost exclusively by the canal.

The attitudes of canal workers changed dramatically within a short time, however, when railroad fever gripped the state and applications began pouring in to charter new roads between various population centers. Many of these were for lines that ran parallel to the Erie and Champlain Canals. Step by step, rail lines were constructed throughout the Mohawk

Valley until only a few small gaps remained. The seventy-eight-mile Utica and Schenectady was opened in 1836 and enjoyed high profits from the start, paying out dividends averaging 10 percent. The Buffalo and Niagara Falls Railroad, at twenty-two miles, opened the following year, as did the Tonawanda Railroad, operating forty-two miles of track between Rochester and Attica. Both companies were also successful, and despite an economic recession in 1837 that caused capital projects to be put on hold, construction of new railroads began as soon as the panic was over. The Utica and Syracuse Railroad, running fifty-three miles through Rome, was opened in 1839 and paid out 10 percent in dividends. The Auburn and Syracuse Railroad and the Auburn and Rochester roads provided further links to the chain, although the lines in this section were circuitous to accommodate connections with Canandaigua, Auburn and Geneva. The Rochester and Syracuse Railroad later straightened out the awkward line.

Elsewhere in the state, legislators were much more supportive of the railroads, even providing state aid in cases where competition with the canals was not an issue. The first loan of state stocks was made to the Delaware and Hudson Canal Company, which was building a series of canals and primitive inclined rail lines from its coal fields in Pennsylvania east to the Hudson River. The company had already spent $1 million in construction, and this was mortgaged to the state to indemnify it against loss.

To mollify villages in the southern part of the state that were bypassed by the Erie Canal, $3 million was loaned to the New York and Erie Railroad in 1836. Two years later, the legislature provided that a dollar of state stock could be issued for every dollar expended by the company. This was later increased to $2 of state stock, and the provision was made retroactive to the commencement of work. Under this law, $400,000 worth of state stock was issued in 1840 and $1 million one year later. The company then announced that it couldn't pay the interest on the original state loan, so it was eventually forgiven. A few other railroads received state funding, such as the Ithaca and Oswego, the Hudson and Berkshire and the Long Island Railroads, in amounts ranging from $100,000 to $300,000 each. Not all of these investments worked out for the state. The Ithaca and Owego Railroad received $315,000, failed the following year and was sold at auction for a mere $4,500.

Throughout all of this railroad building, the canal interests within the legislature, as well as the powerful lobby of businesses and laborers who made a living along the Erie, exerted their influence. Although they could not prevent railroad companies from forming entirely, they added limitations that made it harder for the railroads to compete with the canal. Opposition

or support sometimes depended on which political party was in power or what other events were taking place at the time. For example, in 1838, the Ways and Means Committee said that to maintain the competitiveness of the canal system it would be necessary for the state to borrow $4 million to carry out needed improvements. It was less likely for the state to grant a favorable railroad franchise at a time when it was borrowing huge sums to support the state-run canal.

A study of the language contained in assembly documents that approved each railroad's charter is instructive. The Utica and Schenectady Railroad Company charter stipulated that "[n]o property of any description, except ordinary baggage of passengers, shall be transported or carried on said railroad." It also had to pay $22.50 on each share of the Mohawk Turnpike Company to its shareholders for their expected losses. The Syracuse and Utica Railroad Company charter stipulated that "[d]uring such portions of the year as the Erie Canal shall be navigable, the corporation hereby created shall pay to the commissioners of the capital fund such tolls on all goods and other property transferred, taken, and carried upon said road or ways, except the ordinary baggage of passengers, as the Canal Board shall deem proper, not exceeding the rate of toll charged upon like property upon the said canal."

The Auburn and Syracuse Railroad Company charter was quite similar, requiring that the company pay "the same tolls on all goods and other property transported, taken, and carried on said road, except the ordinary baggage of passengers, as may at the time of such transportation on the said railroad be required to be paid to this State on the same kind and description of goods and other property transported, carried, and conveyed on the Erie Canal." The Rochester and Lockport Railroad charter imposed the same conditions but limited them to that portion of the year in which the canal was navigable. Both the Buffalo and Batavia Railroad and the Tonawanda Railroad were authorized to carry freight from the beginning. The Auburn and Rochester Railroad charter was a bit vague when it came to carrying freight, requiring only that "[t]he Corporation hereby created shall not take and transport merchandise or property in such a manner as to lessen the income of the Erie Canal during the time when the canal is navigable." This vagueness would seem to make enforcement difficult at best.

In fact, there is evidence that enforcement of freight restrictions on the railroads was quite lax. The canal tolls paid by six railroads in 1844 and 1845 amounted to $10,500, or only the equivalent of one day's canal traffic. This finding led to an investigation and a fine for noncompliance with the law.

Even after the railroad charters were amended in the years that followed, most were left to deal with restrictions on both passengers and freight. For passenger traffic, the Mohawk and Hudson was unrestricted; however, the Schenectady and Troy could not charge more than six cents per passenger per mile, the Attica and Buffalo could not charge more than four cents per mile and the rest were restricted to five cents per mile.

Freight restrictions were even tougher. The Attica and Buffalo, the Tonawanda and the Schenectady and Troy were unrestricted, but the Mohawk and Hudson could not receive greater fees than were charged by the Erie Canal, the Auburn and Rochester could not transport freight when the canal was navigable, the Syracuse and Utica and the Auburn and Syracuse had to pay tolls to the canal when it was navigable and the Utica and Schenectady could not carry any freight at all.

Some canal supporters in the legislature soon realized that the danger of railroads charging the public too much was less than the danger of railroads reducing fares much more than the canal company. An effort was made in 1843 to impose new restrictions on railroad operations by requiring that a minimum fare must be charged to passengers. The bill was defeated when several in the legislature pointed out the danger of imposing both minimum and maximum rates that private corporations could charge in the course of doing business. As one dissenter put it, "After the stockholders' money is invested beyond the possibility of recall and locked up in a railway structure, the rates of profit, upon the faith which they made the investment, should not be reduced against their consent."

Bowing to the increased influence of the railroads and pressure from the public, legislators began to lift the restrictions that were placed on the railroads. At first, a bill was passed that repealed the law requiring tolls on freight during the months of January, February and March. In 1844, the Utica and Schenectady was allowed to carry freight in the winter when the canal was no longer navigable. Next was a modification of tolls for shipment of livestock, fresh meat, fish, poultry and dairy products, all of which had to be carried by rail out of necessity. In 1847, the law was changed for the Utica and Schenectady and other railroads to read:

> *The Utica and Schenectady Railroad Company is hereby authorized to take and transport upon its own Railroad all goods, chattels, and other property that may be offered for transportation. The said company shall make returns, at such periods and in such a manner as may be directed by the Commissioners of the Canal Fund, of all goods, chattels, and other property*

*transported upon said railroad by virtue of this act, and shall pay into the treasury of this State the same tolls per mile on all goods, chattels, and other property so transported on the Erie Canal. When the distance by canal from the point of receipt to the point of delivery is greater than the distance by railroad, the amount of toll charged on such greater distance shall be paid by each company in proportion to the length of each road over which said freight shall be transported. The Albany and Schenectady, the Troy and Schenectady, the Syracuse and Utica, the Auburn and Rochester, the Tonawanda, and the Attica and Buffalo Railroad Companies are also required to make returns in the same manner, and subject to the same regulations as are provided in the third and seventh sections of this act, and shall pay the same tolls as is provided for in the said third section. If the transportation of property on the railroad of any company formed under this act, running parallel or nearly parallel to any canal of this State, and within 30 miles of said canal, other than the ordinary baggage of passengers transported thereon, shall, in the opinion of the Legislature, divert business of transporting property from any of the canals belonging to this State, the company owning such railroad shall pay to the canal fund, on all property transported upon its railroad the same tolls that would have been payable to the State if such property had been transported on any such canals.*

A few years after the legislation on freight was modified, Governor Hunt openly worried that Erie Canal business would soon be seriously impaired by competition from railroads. Two years later, Governor Seymour expressed his support of new legislation in favor of railroads, stating, "The public [who in essence owned the canals] will always wish to reduce rates, whereas the railroads will wish to maintain high rates, and hence the canal will be of great value in controlling the rates of transportation." The damaging effect of very low rates charged by the railroads was not foreseen. The newly formed New York Central soon began the practice of dramatically lowering its freight rates during canal season and recouping its losses during the winter, and the Erie Canal was powerless to counter it.

Just a few years later, the decreasing tolls began to cause alarm, and the Committee of Ways and Means introduced a bill to reinstate tolls on railroads. It was finally admitted that even the Erie Canal—with all of its advantages of state funding, little debt and low operating costs—could not compete with the railroads that paralleled it. The bill attempted to divide the railroads into three groups: the first group was to pay regular canal tolls on freight; the second group was to pay two-thirds canal rates; and the third

The greatest limitation of the canals was the suspension of business during the winter months. Here canalboats are shown tied up at their winter quarters in New York City. *New York State Archives*.

group would pay one-half canal rates. However, the mounting influence of the railroad lobby was brought to bear. Thousands of pamphlets and forms were distributed across the state, causing public officials, businessmen and bankers along the rail lines to rise up in protest. The businessmen of New York City added the weight of their influence on the grounds that trade would be taken from the city. As a result of these protests, the bill never made it out of committee.

Despite the defeat, politicians periodically urged that railroad tolls be reinstated. Tolls on the canal itself had to be reduced to remain competitive with the railroads. This was shown in decreased revenues to the state from the year 1851, in which $3.7 million in tolls were collected, to 1859, in which $1.8 million was collected. Had the tolls of the 1840s been retained on the current tonnage, revenues would have amounted to nearly $5 million. One attorney general even asserted that the act that abolished tolls on railroads should be overturned, declaring that it was "a diversion of canal revenues

and as such was unconstitutional and void." No legislative action took place against the toll act, however, as the railroad lobby was too powerful by then.

Even as late as 1850, the disparate railroads along the Mohawk Valley did not take away all passenger traffic from the canals. In several cities, block-long gaps were intentionally left in the rails so that passengers and baggage would be forced to get off one train and hire a conveyance to catch another train, thus giving employment to dozens of local citizens. The idea of baggage checks was still in the future, so the half a dozen transfers of baggage from Schenectady to Buffalo caused much vexation and annoyance. These stops slowed down an already slow trip across the state. A train leaving Buffalo at seven o'clock in the morning reached Rochester at one o'clock in the afternoon, Auburn at seven o'clock in the evening and Syracuse at nine o'clock at night. Passengers would remain in Syracuse overnight, since sleeping cars were still in the future and a bumpy ride of fourteen hours called for a much-needed rest. Snowstorms often caused delays of a few hours to a few days.

An effort was made by the railroads to eliminate some of these annoyances. The primitive iron tracks were all torn up and replaced with heavy steel rails. The tracks were then united along the entire length from Albany to Buffalo, eliminating the need to move from one train to another. New locomotives and cars were placed into service capable of increasing traveling speed from an average of twenty to thirty-five miles per hour. As a result of these initiatives, the public flocked to the railroads in record numbers.

Even with passenger traffic on the Erie Canal dwindling, revenues from freight remained high. In 1851, new appropriations were set aside to expand the canal to accommodate larger boats that could remain competitive with the railroad system. During that same year, bowing to public pressure and the increased power of the railroads, the state officially abolished all canal tolls, allowing railroads to carry freight without restriction for the first time in their existence.

When the dozen railroads were merged into the New York Central, schedules were fully coordinated into an efficient transportation system that ended the era of canal passenger travel forever. However, the canal actually saw an increase in freight revenues as a deluge of agricultural goods and timber began to pour in from the West. The railroads were much more efficient than the canal in moving people and perishable goods, but in nonperishable bulk goods, the canal kept a slight edge. It became the country's most valuable transportation link during the Civil War when other routes were either too expensive or too close to the fighting. The blockade of

the Mississippi River in the early days of the war meant that all shipments from the Great Lakes had to be funneled into the Erie Canal or St. Lawrence River. In 1865 (the year that the Civil War ended), the Erie Canal shipped 2.5 million tons of freight, compared to 2.2 million on the Erie Railway and 1.3 million on the New York Central.

Efforts were made by canal authorities to keep pace with the technological advancements of the railroads, to little effect. Various methods of steam propulsion were attempted beginning in 1870, following the practice of the Belgian system in which boats were towed by cables laid along the bottom of the canal. Grants were made to several canal steamboat companies to test it. In the meantime, new contraptions were installed to accelerate the raising and lowering of lock gates, and new reservoirs were created to feed more water into the canal to accommodate the increasing traffic. The Baxter Steam Canal Boat Company introduced a boat ninety feet long capable of transporting two hundred tons of freight.

Meanwhile, advancements in railroad technology far outstripped those that were taking place on the canals. In 1851, the state engineer of New York estimated in his annual report that it would take six double-track railways to match the freight business of the Erie Canal. At that time, ten tons of freight or 330 bushels of wheat constituted a standard carload, while fifteen cars made up a typical train. Once steel rails were introduced to the New York Central, larger steam locomotives were purchased that could haul fifty cars holding 50,000 bushels of wheat in one train.

The railroad rate wars, described in more detail in the next chapter, also negatively affected canal traffic. One particularly drawn-out war among the railroads during the summer of 1875 led some to question whether the Erie Canal would even survive. Several trunk railroads formed an agreement called the "Saratoga Compact" that set rates at historically low levels. When the Baltimore and Ohio Railroad refused to be bound by the pact, competition for freight became even more pronounced. State authorities could only watch as freight rates were cut so low that shippers delivered nearly all of their goods to the railroads. Authorities calculated that canal revenues would not be enough to cover expenses for management and ordinary repairs. Some recommended that tolls be lowered in an effort to get some of the freight business back, but because the state only owned the canal and not the boats that plied it, it could only control part of the rate equation. The public would have benefited in the long run if railroad rates were permanently set below the cost of transporting freight by water, but with rates set artificially low by cutthroat competition, it was necessary for

# Canal Wars

Despite immense competitive pressures from the railroads, the sight of hundreds of canalboats in New York cities such as Buffalo was a common one well into the late 1800s. *Library of Congress.*

the state to maintain the canal even at a loss in order to prevent the railroads from gaining a monopoly on bulk freight traffic.

As with any project supported by public funding, the canals bred corruption. Money was liberally expended in questionable ways, such as using favored contractors in exchange for kickbacks. A committee appointed to investigate the management of canals found that the loss of money to the state by frauds over a ten-year period amounted to several million dollars. One such incident occurred when various contractors held a meeting at Stanwix Hall in Albany. Exclusive bids were auctioned off among themselves at much higher rates than if sealed bids were made. The amount of money collected was then divided up, and the successful bidder recouped himself by adding the amount to his bid. The other proposals were declared "dummy bids" and rejected for nominal reasons. When the proceedings were discovered, the contracting board was found guilty of collusion with the contractors.

The lack of personal investment in the canals led to mismanagement and inefficiencies, which further weakened their cause. The failures of the contract system reached a peak in 1870 when it was blamed for the accumulation

of silt and mud in the bottom of the canals, leading to interruptions of navigation. As a result, the contracting board and the system of repairs made by contract were abolished.

A significant advantage of the railroads over the Erie Canal was also rooted in their diversification. The railroads began purchasing lines of steamboats that plied the waters of the Great Lakes, Lake Champlain and the Atlantic. At one point in the 1870s, there were few lake steamers that did not constitute a part of some through-line by water and railroad in New York. Once freight was loaded on these steamers at Chicago, Milwaukee or any other Great Lake port, the freight was substantially under the control of the Erie or Central Railroads. The Western Transportation line of steamboats connected with the New York Central at Buffalo, while the Union Steamboat Company connected with the Erie Railway at Chicago. Other combinations included the Anchor Line with the Pennsylvania Railroad at Chicago, the Sarnia Line with the Grand Trunk Railroad and the Northern Transportation Company with the Central Vermont Railway out of Ogdensburgh. Each of these steamboat lines either had a prorating arrangement with a particular railroad or was under its direct control.

The multiple steamboat connections at Chicago are an indication of the shift of commerce westward throughout the century. "Fast freight lines" were formed by the railroads to take advantage of new markets in the Far West. These freight lines had agents stationed in all the western cities who solicited traffic for them. Since the local rates to lake ports were greater per mile than the through rates to the East, a large amount of traffic was diverted from the lake and canal lines. The Erie Canal had no such agencies and instead was forced to rely on shippers who specifically brought freight directly to the canal itself.

With a route that could not be moved or easily extended, the Erie and Champlain Canals were limited to shipping grain and lumber to Albany and New York City. Much of the grain transported from western points was destined for interior towns and cities, far from the reach of the canal, and therefore had to be transported by railroad. It was cheaper to send grain directly to an interior town by rail, even with its higher rates, than to send it by water to New York City, where it incurred terminal charges, and then by some other form of shipment to the final destination.

Of course, the canal's greatest weakness was on full display each winter when the shallow, slow-moving water quickly froze over and halted all navigation. During some rare seasons, the canal was kept open well into December, but it was sometimes closed much earlier. For example, in 1901, a

# Canal Wars

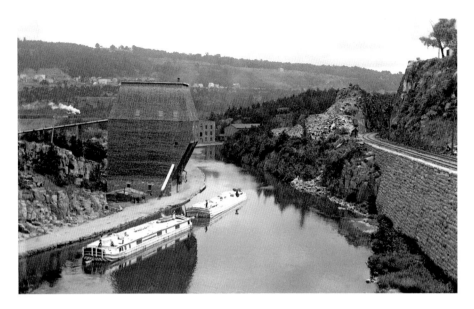

By the time this picture of the Erie Canal and West Shore Railroad at Little Falls was taken in 1890, the railroads were hauling 97 percent of the nation's freight. *Library of Congress.*

sudden bout of cold weather in November caused 175 canalboats to become icebound. About 55 boats were loaded with grain, while others were loaded with much-needed lumber. The shippers demanded that the cargoes be delivered by rail, since their contracts did not provide for delay on account of freezing. The boat operating interests refused and proposed to deliver the grain in the spring. No doubt incidents such as this one only exacerbated the perception that the era of the canal was coming to an end. In fact, later that year a legislator proposed that the state abandon the canal and build an electric railroad from Buffalo to Albany in the canal bed.

Despite the Erie Canal's disadvantages, mismanagement and corruption, income continued to rise after the Civil War to $4 million per year, while gross tonnage continued to climb until 1880, where it peaked at 4.6 million tons annually. Some commodities, especially those that were exported directly from the port at New York City to other states and countries, were shipped almost exclusively by canal. Shipping rates for wheat in 1870, for example, averaged 18.3 cents per bushel by rail versus 13.1 cents by canal. Corn cost 17.3 cents per bushel by rail and 11.3 cents by canal. The potential savings in shipping nonperishable commodities by canal gave distributors a reason to continue utilizing it for decades. The total amount of money collected from

tolls when they were abolished in 1882 was $121 million, and the amount of taxes collected on behalf of the canal fund added another $38 million, making the Erie Canal one of the most profitable state-funded projects in history.

To keep up with the increased size of canalboats, the Erie Canal underwent a $32 million enlargement project beginning in 1846 that lasted for fifteen years. The original dimensions were increased from forty feet wide to seventy feet, while the depth was increased from four feet to seven feet. The locks were enlarged and doubled so that boats going in both directions could enter them at the same time. The size of boats plying the canal after these renovations were completed increased from 76 tons to 250 tons.

Although the state's canals continued to carry significant amounts of freight, by the end of the nineteenth century, their business was largely dictated by the actions of the railroads. For example, in 1893, the canals carried a combined 4.3 million tons of freight. Agricultural products made up about 30 percent of that number, while lumber made up another 25 percent. In terms of hauled tonnage, the Erie Canal was by far the most important carrier at 3.2 million tons, followed by the Champlain Canal (850,000 tons), the Black River Canal (116,000 tons), the Oswego Canal (92,000 tons) and the Cayuga and Seneca Canal (39,000 tons). The total amount of grain received at the Port of New York totaled 109 million bushels, of which the canals carried 40 percent. This was in stark contrast to the previous year, when the canals carried only 23 percent of the grain. The sole reason for this change was a temporary increase in railroad freight rates during the economic recession as railroads attempted to maintain profits. As soon as the recession was over, rail rates dropped and canal business plummeted.

Between 1835 and 1882, railroad mileage in New York State increased from 100 to 6,600 miles; alignments and grades were straightened and reduced; the New York Central was quadruple-tracked and the Erie Railway double-tracked; and locomotives increased their power by five times. This rapid development relegated the canals to obsolescence and made competition impossible. After the tolls were abolished, the canals remained solvent through public taxation rather than from generating revenues. Steam transportation on the canals had proven to be a failure, and no other technological improvements succeeded or were even attempted. In the 1890 federal census, it was reported that all of the nation's canals carried 21 million tons of freight compared to 620 million tons by the nation's railroads. The canals won several hard-fought battles in New York State, but the railroads ultimately won the war.

# Rate Wars

At a time when few regulations existed to control the actions of the nation's great transportation systems, rate wars were often fought among the trunk lines to develop business along a new route and later draw business away from the competition. In the process of doing so, the state economy was sometimes thrown into disarray, the stock market wildly fluctuated and passengers and shippers were left to wonder what prices they would be paying in the days to come.

Rate wars were almost as old as the railroads themselves, but among the most notable were between the New York Central and the New York and Erie Railroad, which became the Erie Railway in 1861) when the latter reached the Great Lakes at Dunkirk, giving it access to Chicago. These wars cost the companies millions of dollars in lost revenues and were the subject of intense public interest. Often there were no winners—rates would eventually rise back to their former levels or even higher as the railroads attempted to make up their losses. In the meantime, several new railroads were constructed that paralleled existing lines in an effort to gain the upper hand, wasting tens of millions more.

New and much more damaging wars broke out in 1874 when the Pennsylvania Railroad blocked the Baltimore and Ohio Railroad's access to Chicago, triggering a severe rate war that involved the country's four trunk lines. A short peace prevailed until the struggle broke out again in 1881, intensified by the construction of new parallel trunk lines (the West Shore and Nickel Plate Railroads) that competed directly with the Erie and the

Despite suffering from chronic mismanagement, the New York and Erie Railroad (later renamed Erie Railway) was the longest in the country when it was completed, and early connections extended its reach to Chicago and beyond.

New York Central. Yet another rate war erupted when the two New York railroads lowered freight charges on dressed beef and other freight to draw traffic away from Canada's Grand Trunk.

Early in the history of railroads, there were so few of them that rate wars were unheard of, but there was little doubt that as new lines stretched across the state and country, competition would soon develop. Even before the ten little railroads of the Mohawk Valley merged to form the New York Central, company officers called for a railroad convention to be held in Buffalo for the purpose of finding agreement on fares among the eastern railroads. Little progress was made as too many railroad managers had opinions of how rates should be set and enforced.

This somewhat informal meeting was followed in 1854 by the famous "St. Nicholas Convention," named after the New York City hotel in which it was held. It was attended by the New York Central, the Erie, the Boston and Albany, the Pennsylvania and the Baltimore and Ohio Railroads, representing all of the country's trunk lines. Erastus Corning, president of the New York Central, called for uniform rates and an end to the cutthroat tactics that railroads were using to take business from one another. For example, some lines paid "runners" to ride the trains of competitors and exaggerate the advantages of their own system or proclaim the horrors of riding on other rail lines. Corning thought it was important that each railroad respect the territory of others and operate within a community of common interests.

The results of the St. Nicholas meeting were comprehensive. The railroads all agreed that they would charge the same first-class passenger fares and freight rates between New York and any point west of Buffalo, Dunkirk or

Pittsburgh, the rates being determined by the four trunk lines as needed. It was also agreed that local rates would not be less than through rates, all rates would be fixed, all freight would be classified in a uniform manner, all free passes would be abolished and the use of runners and soliciting agents on rival railroads would come to an end.

Had the companies stuck to this agreement, they would have reaped much higher profits over the next decade. As it was, controversy arose immediately when the press declared it to be "a combination of railroad companies against the public" and "a giant scheme for plunder." Others warned that it was the beginning of a new monopoly on public transportation that would "breed mobs and cause violence to railroad property." The agreement lasted a mere six months before it was breached by the Erie Railway when that company lowered its through passenger fares to New York City. New York Central president Erastus Corning responded by opening a ticket office in New York and establishing a day-and-night line of steamers along the Hudson River to provide low-cost passage from New York to Buffalo. This was necessary because the Central's tracks only reached from Buffalo to Albany, and since Corning was unable to secure an advantageous agreement with the Hudson River Railroad to convey its passengers from Albany to New York, a boat line was the only alternative.

The Erie had nearly the same disadvantage. Its line ended at the small village of Piermont on the west bank of the Hudson, twenty-five miles north of New York City. The rest of the trip was completed by steamboats, partly alleviated later when the tracks were extended to Jersey City. The Erie had an advantage in that the trip was slightly shorter and, because the Central was hampered by the long water route down the Hudson, slightly faster. However, the Central boasted of the "Water-Level Route" through the Mohawk Valley, providing a much smoother and more comfortable ride. The Central also used less motive power, since there was only one steep grade on the entire line (near Albany), so its western route was less expensive to operate.

The contest between the two New York railroads escalated into open warfare in June 1855, when the Erie cut its passenger rate between New York and Buffalo to $6.50, which was $2.50 less than that of the Central. The Central responded by establishing a "cheap train" with a fare of $5.25 from Buffalo to New York.

This ruinous state of affairs proved to be so expensive to both companies that a truce was made a short time later. This lasted until 1857, when the formation of the Lake Shore Railroad indirectly led to an abrupt end to

Advertisements for the New York and Erie Railroad boasted of the "safety and comfort" of its broad-gauge track. This 1856 broadside also reveals the railroad's extensive connections, spanning from Boston, Massachusetts, to Rock Island, Illinois. *New York State Library.*

# Rate Wars

the peace. The State Line, Michigan Southern and other railroads merged to form a powerful new trunk line leading west from Buffalo. The Central proposed that the Lake Shore Railroad establish an express train from Buffalo to Chicago so that both the Erie and Central Railroads could coordinate their own trains to meet it. The Erie quickly provided such a train, but patronage wasn't high enough to sustain the endeavor and was discontinued. The company then proclaimed that any passengers arriving from the Chicago express train at Dunkirk would be carried east in the morning at a reduced fare. The Central protested this policy, alleging that the arrangement was just an excuse to lower fares below the numbers agreed on. Exerting its influence, the Central persuaded the Lake Shore to refuse to honor Erie Railway tickets. The Central itself charged double fares to those who presented Erie tickets at Buffalo. The Erie, with Daniel Drew at the helm, slashed its rates to New York lower than even during the rate wars of two years previous.

This time, the rivalry took on an almost personal tone, as railroad management on both sides resorted to attacking the other company while extolling the virtues of traveling on their own railroad. The following broadside was widely circulated throughout the state by the New York Central:

> *Passengers taking this route can feel assured that they are with careful and experienced engineers, the Company paying well for such, never having been obliged to use firemen with no experience on account of strikes endangering life, and never making time as is the case on the "GREAT BROAD GAUGE ROUTE." Passengers should be particular and secure tickets by this route, as it is the only one having a uniform gauge from Cincinnati to Buffalo, thence to New York and Boston; saving several changes of cars and baggage and the annoyance of missing connections, which occurs so often on the New York and Erie Route. THIS IS THE ONLY ROUTE that can land passengers by cars in New York City within a short distance of the principal hotels. All other routes land their passengers in Jersey City, compelling them to procure the services of porters and hacks, crossing the river, making an additional and disagreeable change, incident to the New York and Erie Road.*

The Erie responded in kind, calling the New York Central the "Albany Narrow Gauge Route that constantly misses connections at both Buffalo and Albany, causing delays of from six to ten hours." It was also quick to point out the glaring omission of the Central's advertising: passengers were

not landed directly in New York City but rather at a ferry in Albany. On the back side of one such Erie broadside was the following "testimonial" to the traveling public:

> We, the undersigned, from a desire to promulgate correct information and to prevent others from being subject to the impositions of which we have been the victims, beg to offer the following statement: On our arrival (on the morning of the 3rd of March, 1857) at Suspension Bridge from Detroit, we were immediately beset by runners purporting to be employed by the New York Central Railroad. These assured us (and presented handbills in support of their allegations, officially signed) that the New York Central R.R. was the only road to New York, landing its passengers in the heart of the city and 22 hours in advance of any other route. Prejudices previously formed were so overcome by these representations that our party, originally six in number, separated and four of us took the narrow cars. Instead of coming directly to New York, we were landed at Albany, where, after a detention of about an hour, we were ferried across the Hudson River and, by dint of walking fifteen or twenty rods through the mud, reached the cars of the Hudson River Railroad. After another tedious delay there (the narrow cars again) got under way and arrived at, not in New York about 10 o'clock at night, but three miles beyond the business portion of the city. Here we were taken in town by horses and another ride of an hour brought us downtown. It was now half-past eleven o'clock at night. The arrivals by the New York and Erie Rail Road an hour and forty minutes before, and not twenty hours later, had so filled up the hotels that we had great difficulty in procuring lodgings for the night. We have simply to say, in conclusion, that we consider ourselves grossly imposed upon by the representations made to us at Niagara Falls, and here let us say that we exonerate Messrs. Vibbard, Corning & Co., from any participation in this, believing them, and for the public good, and to prevent others ignorant of the true merits of the case from being deceived, confidently hoping that an exposure of these abuses may tend to their cessation and eradication, we publish the facts set forth and hereunto subscribe our names.

A short truce was called in mid-1857, but by the spring of the following year, the two railroads were battling once again. The Erie slashed fares, forcing the Central to follow suit. Passengers could travel from Buffalo to New York for as little as five dollars. A summer railroad convention was called in Buffalo in which representatives from eighteen railroads attended.

# Rate Wars

The Erie was formally requested to restore its normal fares, but company president Charles Moran refused and walked out. The convention ended without a compromise.

A second convention was organized the following month in Cleveland. This time, the Erie Railway was not invited. It was decided that the railroads in attendance would no longer exchange coupon tickets with the Erie until the company restored its fares. President Corning, in fact, refused to recognize any railroad that did business with the Erie. However, some western railroads like the Michigan Southern refused to play along. For a while it appeared that the convention would be as fruitless as the first one. However, the Central's much stronger financial position gradually eroded the Erie's passenger business. The New York Central was able to wield a greater influence over connecting lines and thus force the Erie to restore normal fares. Once fares were made uniform, business gravitated to the Water-Level Route with its faster trains and connections to the state capital. In addition, the Erie suffered from poor management, an engineer's strike and a devastating flood in the Delaware Valley that destroyed miles of track. It was, however, able to maintain an edge in the freight business, shipping 4.8 million tons in 1870 compared to 4.1 million tons shipped by the New York Central.

In the meantime, the project of double-tracking and later quadruple-tracking the entire New York Central mainline from Buffalo to Albany was completed, allowing it to handle even more freight and passenger traffic. The Central's only remaining weakness was its lack of a rail entrance into New York City, accompanied by the almost ridiculous bottleneck in Albany where passengers had to disembark and cross the river by boat to catch a train in East Albany. This weakness would be remedied in the following decade when a bridge was constructed and the company was merged with the Hudson River Railroad to provide one continuous, all-rail route from Buffalo to downtown New York City for the first time.

Another bitter but short-lived rate war between the railroads took place in the middle of the so-called Great Erie War. At the time, the officers of the Erie (Daniel Drew, Jim Fisk and Jay Gould) were living as fugitives in New Jersey after having cheated Cornelius Vanderbilt out of $7 million in fraudulent stock sales. With a warrant for their arrest waiting for them on the New York side of the river, the trio struck back in any way they could. One way was to hurt Vanderbilt's pocket at the very time he was suffering the most (having lost so much to the Erie Ring). They announced that the Erie was going to cut both its freight and passenger rates by one-third from

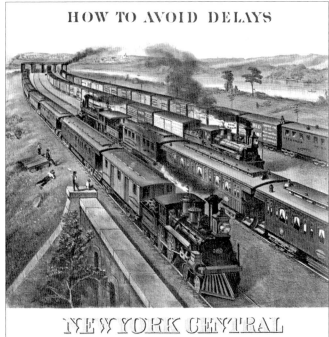

The New York Central touted its famous four-track water-level route across the state in an effort to lure passengers away from the more mountainous New York and Erie Railroad route.

# Rate Wars

New York to Buffalo. The passenger fare of $5.00 was so low, in fact, that neither the New York Central nor the Erie could afford it, but the difference was that Vanderbilt cared about the financial stability of his railroad, while the Erie Ring did not. Drew also announced that his steamboats were going to start a $0.50 fare line of boats from New York to Albany, cutting into the profits of Vanderbilt's Hudson River Railroad. These actions cost both railroads millions, which vexed and irritated Vanderbilt to no end. During one particularly severe rate war when the price of shipping freight was cut to the bone, Gould purchased vast herds of sheep—the most undesirable and unprofitable freight—and shipped them on the New York Central at a profit of more than $1 million.

Another round of rate wars occurred in the years immediately following the entrance of the Baltimore and Ohio and the Grand Trunk Railroads into Chicago in 1874. The New York Central, the Erie and the Pennsylvania Railroads were anxious to protect the business they already had and slashed rates indiscriminately. The usual charge of $1.88 for first-class freight from Chicago to New York plummeted to $0.25. Grain rates of $0.60 fell to $0.30, while commodity rates were sometimes quoted as low as $0.12. A truce was called to allow the trunk lines to recover, but a year later they were at it again, charging $0.20 per ton to ship grain from Chicago to New York. The lines finally submitted to arbitration as the Erie and the Baltimore and Ohio Railroads were nearly bankrupted.

Despite the decline of the Erie Railway, rate wars between the Erie and New York Central flared up sporadically over the next two decades, especially when economic disruptions caused a decline in freight shipments. A rate war among many of the eastern railroads was particularly long-lasting in the early 1880s. A joint executive committee of the trunk line railroads and their western connections met in the summer of 1881 to attempt a reconciliation. The commissioner stated that the Erie Railway had signed "time" contracts of five to ten cents per hundred pounds below what other railroads were supposed to be charging for shipment. As proof, the Erie carried 2.3 million more bushels of grain to New York City during May than during the same month the previous year. Meanwhile, the New York Central shipped 53,000 bushels less than the previous year. The same occurrences happened in June and July. The representatives of the Erie replied by walking out of the meeting. New York Central officers said that they were now at liberty to bid on freight shipments at any rate they deemed prudent. The meeting ended in the same manner as most other meetings of this sort, with no agreement to end the hostilities among the trunk lines for either freight or passenger traffic.

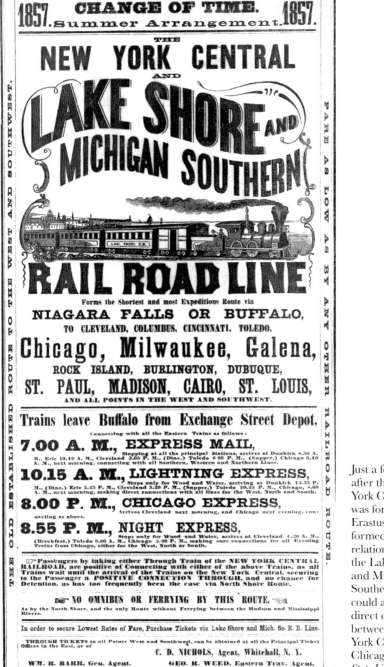

Just a few years after the New York Central was formed, Erastus Corning formed a close relationship with the Lake Shore and Michigan Southern so he could advertise a direct connection between New York City and Chicago. *New York State Library*.

# Rate Wars

The so-called rate wars would seem to have benefited the public to a great degree, enabling people to travel long distances for very little money. However, there were several adverse consequences from these wars. During the years in which fares were cut to the bone, stock dividends were canceled, causing hundreds of thousands of stockholders to lose badly needed income. Men were laid off by the thousands, and those who kept their jobs were subjected to painful wage cuts. The loss in discretionary income led to a general depression of business as the ripple effect of all those wage earners tightening their belts was felt throughout the economy. The rate wars that were fought between the New York Central and the Pennsylvania railroads greatly exacerbated the depression that hit in 1873 and caused it to last several years.

Railroad executives were often exasperated by the actions of other railroads. Although the most infamous rate wars were started to manipulate stock prices or destroy a competitor, most were the result of a depression of business. Alarmed officers would react by cutting rates to lure passengers from parallel lines, only to watch as their competitors cut their rates to match. In July 1881, the *New York Times* noted that ticket offices were usually crowded with people taking advantage of ticket prices to the West that were dropping by the hour. On one morning, rates to Chicago were posted at $11.00 and to St. Louis at $15.25. Later in the day, rates to Chicago were reduced to $9.00 on all lines. In an interview, the general passenger agent of the Erie Railway was confused by the sudden rate cutting and could not understand why a company would open this competition "when it was only to be done at a great loss of money." The passenger agent for the Pennsylvania Railroad was equally confused and said that all he could do was watch the other companies and make the same reductions.

Sometimes this strategy backfired. A little later that summer, the Grand Trunk Railway (operating through Maine and Canada) lowered its fares from Boston to Chicago to five dollars. Officers of the New York Central held off lowering its rates and were gratified to see that Central train levels between the two cities remained steady. Apparently, most passengers were willing to pay extra to avoid the long detour through Canada to get to Chicago. But the majority of rate wars simply resulted in a net loss of profits to all parties and no appreciable change to the overall popularity of one line over another.

William Vanderbilt, who took over the affairs of the New York Central when his father Cornelius passed away, was open to a so-called railroad pool in an effort to mitigate the rate wars that cost the companies so much money.

Access to large deposits of coal gave the Pennsylvania Railroad an advantage over the New York Central and Erie Railroads, as hauling raw materials provided a steady stream of traffic for the trunk lines. *Library of Congress.*

A pool was used by groups of railroads that served a geographic area and functioned by members putting all of their earnings together and distributing them on a proportional schedule, based on the amount of business that was done by each before the pool was put into effect.

The "pool" idea was used by other railroads in the past but was subject to financial abuses. Nevertheless, the Panic of 1873, followed by years of recession, persuaded the weary directors of the Central and the Erie to attempt an agreement. Vanderbilt's favorite summer resort was Saratoga, where the racetrack provided an ideal showcase for his championship trotters, and the stately United States Hotel provided a dignified place to work out a compromise. He was joined by the presidents and managers of the Erie and Pennsylvania Railroads, along with their western connections (the Lake Shore, the Fort Wayne and the Atlantic and Great Western). The result of this well-publicized meeting was the Trunk Line Pool, in which the New York Central and Pennsylvania were allotted 33 percent of all westbound freight, the Erie was allotted 25 percent and the Baltimore and

# Rate Wars

Ohio (whose representatives were not invited) was allocated 9 percent. If one of the railroads exceeded its allotment, it would have to pay the other railroads the difference. In this way, none of the four railroads had any incentive to carry more freight than was set in the pool—hence, there was no incentive to lower rates.

For almost two years, the pool system stabilized fares and allowed the eastern railroads to recover financially. A German-born civil engineer named Albert Fink, who made a study of transportation costs, was hired to collect and analyze railroad rates around the country. By monitoring both commodity rates (fixed for a given commodity) and class rates (which were the same for all items in a particular class), Fink kept the four trunk lines and its customers happy for the first time in many years. Within a few months, nearly all of the rail lines of the Northeast, twenty-five in total, had signed up for the railroad pool.

The system was working so well that when Vanderbilt attempted to modify it to accommodate new lines, his efforts were futile. Newer companies were more likely to violate the agreement in an effort to establish a customer base. Vanderbilt and others resorted to using rebates to large customers and making up any losses by charging small companies more. The use of rebates was widely used until federal regulations banned them in the early 1900s. Gradually the Trunk Line Pool fell apart as more participants violated its terms, and the rate wars began all over again.

The power of the Central and Erie within the legislature is illustrated by the lack of laws that regulated railroads in New York. Pools or combinations of railroads against others were forbidden in the constitutions of nine states, including Pennsylvania and Ohio. The use of rebates was outlawed in five states, while the practice of charging more for a short haul than for a long haul over the same line was forbidden in five states. The fact that none of these practices was outlawed in New York gave the two trunk lines much greater latitude to enact discriminatory pricing that ultimately had a negative impact on the state's industrial growth.

Railroad law in New York also made it legal for anyone with the money and audacity to build lines parallel to any other, regardless of the commercial viability of such a venture. This was often done simply to compel the existing railroad to purchase the new one at a profit to the organizers or risk insolvency. This idea led to the construction of two brand-new railroads and a new round of wars involving most of the northeastern rail system.

The first of the two new trunk lines was the New York, Chicago and St. Louis Railroad, nicknamed the "Nickel Plate." In 1881, a capitalist named

George Seney constructed a line parallel to the Lake Shore Railroad from Buffalo to Chicago via Fort Wayne, Indiana. The company issued $50 million worth of stock and $19 million worth of bonds for construction. Within just a few months of opening, the stock declined from sixteen to ten as William Vanderbilt actively campaigned against it in the press and on Wall Street. A popular story arose in relation to how William Vanderbilt was tricked into buying the Nickel Plate for more money than it was worth. Calvin Brice, an attorney and later Ohio senator, was part of the Seney syndicate and put all of his savings into the project. To save himself from ruin, he approached Vanderbilt to buy the Nickel Plate, but Vanderbilt replied that he knew the company was in trouble and so he could afford to wait for the first mortgage foreclosure and "buy it from the sheriff." Brice warned, "If you don't buy it, Jay Gould will." Again Vanderbilt refused, calling the railroad "a string of dirt leading from nowhere to no place."

Growing increasingly desperate, Brice went to Gould with a proposition. If Gould would sit silently and neither confirm nor deny any newspaper article that suggested he was going to buy the Nickel Plate, and a week later take an excursion ride over the line in an observation car, Vanderbilt would buy the road and Brice would give Gould $500,000. Gould was too wealthy to be bought for that sum, but it struck him that the whole thing would be quite a joke on Vanderbilt. Accordingly, stories came out that Gould was preparing to buy the Nickel Plate, and at the end of the week, he rode at the rear end of an observation car, smoking a cigar and assuming the air of someone who was reviewing a piece of investment property. Stories were wired about Gould's trip from every station along the way, and before Gould had reached Chicago, Vanderbilt wired Brice that he would take the Nickel Plate.

Whatever the true story, Vanderbilt made a rare tactical error when he paid seventeen dollars per share on behalf of the Lake Shore for the common stock, as the railroad was rapidly heading toward bankruptcy. Upon reviewing the books after he purchased it, Vanderbilt realized that he could have saved hundreds of thousands of dollars if he just waited a few more weeks. Thus, the Lake Shore was saddled with the burdens of carrying the Nickel Plate on its books, which reduced the already shaky Lake Shore dividend payout for years to come.

This lesson would not be forgotten by Vanderbilt when the next competitor emerged on the scene. The idea for a railroad line on the south bank of the Mohawk River was first broached in the 1840s when the Mohawk Valley Railroad was chartered by men who wished to connect

# Rate Wars

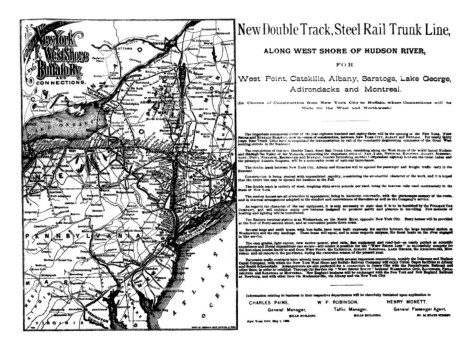

The New York Central naturally viewed the construction of the West Shore Railroad as a direct threat to its business, leading to intense rate wars that affected all northeastern rail traffic. *Joseph A. Smith Collection.*

Troy and Boston with Buffalo, circumventing the lines on the north side of the river. This was never built, and the charter was merged into the New York Central. The Erie Railway at one time attempted to revive this idea in order to secure its own route to Boston via the Troy and Boston Railroad, but the charter was blocked by the Vanderbilt interests.

The profits that the Central enjoyed by possessing the only "water-level" route across New York were hard to ignore, however, so the idea was revived in the form of the New York, West Shore and Chicago Railroad. Surveys were made and ground was broken until a financial panic brought work to a halt. A few years later, the railroad was reorganized as the New York, Ontario and Western, and construction of a four-hundred-mile-long double-track line was undertaken. Tunnels were bored through hard flint rock, huge bridges were thrown over deep ravines and millions of dollars were spent on the right-of-way through some of the most densely populated areas of the state.

The expensive undertaking would have collapsed under the weight of its financial needs had it not been for the support of many communities

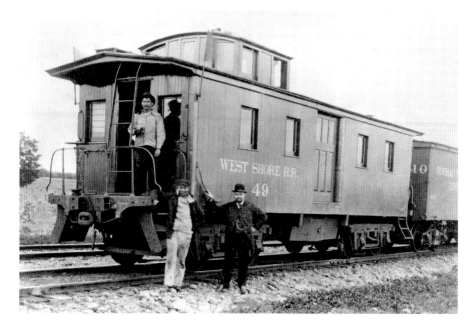

The West Shore Railroad became a thorn in the side of William Vanderbilt as soon as trains began running in 1883. *Joseph A. Smith Collection.*

along the line who felt snubbed by the New York Central. George Pullman of the Pullman Car Company also put his wealth behind the enterprise, allegedly because he was upset that Cornelius Vanderbilt, long before, had partnered with the Wagner Palace Car Company and refused to let any Pullman cars on the Central lines. Even so, the $50 million price tag was virtually unheard of in those days and saddled the company with such high mortgage debts that it wasn't prepared to fight the much more prosperous New York Central.

To the great relief of company officers, construction of the roadbed and tracks finally reached Buffalo at the end of 1883, although there wasn't enough money left over to build the imposing passenger station that was planned for the city. Instead, a temporary structure served as a shelter while the first train schedules were announced. The distance of the route between New York and Chicago was 954 miles, compared to 961 miles for the New York Central and Lake Shore combination. The slightly shorter distance did not equate to a shorter ride, however, as the experienced trainmen of the Central were able to send trains much faster and more efficiently over their lines. Moreover, the Central began

# Rate Wars

a rate war in an attempt to crush the fledgling railroad before it became too entrenched.

There are indications that the West Shore syndicate was willing all along to sell the line to William Vanderbilt, but of course it wanted a stiff price. Vanderbilt, on the other hand, had learned from the Nickel Plate episode. Therefore, Vanderbilt set out to destroy the West Shore Railroad in the marketplace and assume control in his own time. As soon as the line opened for traffic, he lowered rates on the New York Central to such an extent that all the other trunk lines in the country were forced to follow suit. Rates from Albany to New York were cut by more than half. The West Shore was forced to meet these cuts even though it was not able to absorb losses for any length of time due to its low cash reserves.

By the following summer, the rate wars were having a devastating impact on the financial health of the West Shore. The revenues coming in did not even cover the mortgage interest on its construction bonds, let alone operating expenses. In June, the State Supreme Court declared the company bankrupt and appointed receivers to manage the finances. Receiver certificates were issued to cover payroll and other pressing bills while a strategy was worked out to address the pricing tactics of the New York Central.

Contrary to the actions of most railroad receivers, who normally worked to economize expenses and get a company out of debt, the West Shore receiver acted with aggression toward the Central. Receivers had the power to issue certificates in order to keep a railroad in good working order, but they were almost never used to pay for expenses. In stark contrast, the West Shore receiver issued certificates that ranked for payment before the first mortgage bonds to keep the company running. He then lowered freight and passenger rates to unprecedented levels to force the Central into suspending the rate war, reasoning that the Central was losing three dollars for every dollar that the West Shore was losing. Vanderbilt calmly lowered his own rates to meet those of the West Shore while bringing suit against the receiver to prevent him from issuing any more certificates for working expenses.

Local passenger fares soon hit an all-time low of one cent per mile, and citizens from all over Upstate New York happily rode the rails in record numbers. However, the West Shore still could not compete with the Central in running time, held back by inexperience and single track lines between some villages. Patrons were willing to pay a bit more to ride the Central and for its more reliable schedules and shorter traveling time. The West Shore responded by cutting prices yet again, this time the through passenger fares from New York to Chicago. The normal fare charged by both the Central

and the Pennsylvania was $12.00. The West Shore cut its fares to $10.50, claiming that it had the right to charge less because its trains were slower than those of its rivals. The Erie, Lackawanna, Central and Pennsylvania Railroads all responded by cutting their fares to $10.50 as well. The West Shore then reduced fares to $9.00 and later went as low as $8.30.

William Vanderbilt reacted to the rate war with disgust. He argued that the West Shore should never have been built, since its only purpose was to take traffic from the New York Central and was never intended to generate additional freight shipments. "I look on the West Shore road just as I would on a man who has been found in my money drawer, a common, miserable thief," he said. "The fact is we have got the thief's hand firmly caught in the drawer and we are going to keep it there, too."

The actions of the receiver doomed the West Shore to ever declining revenues and bad press. Even the *London Economist* felt strongly enough to write, "The West Shore is a convenience to no one; it is destructive to vested rights; there is no necessity for its existence; and it is an injury to that locality and to the public, which needs the perfecting of existing lines rather than the building of new ones parallel thereto." The *New York Herald* wrote, "The Central's fight is for self-preservation. It will be fully justified if it shall continue it long enough, and make it severe enough, to render the building again of such lines as the West Shore an impossibility for many generations."

The results of these latest fare wars were tough on all the railroads but downright disastrous for the West Shore. In September 1884, the company reported total receipts of $3 million and expenses of $3.6 million. It could not even pay the rent on the temporary waiting station in Buffalo and was temporarily locked out by the landlord.

The railroad limped along for several more months, but the cash losses continued and no further funding was possible. The lawsuits brought against the receiver for issuing "operating expense" certificates appeared to be going against the West Shore, and if they were successful, the railroad would be forced to cease running trains altogether. William Vanderbilt was among the few people in the country who had the incentive and the funds to bring the West Shore into the Central's orbit, which he did in the summer of 1885. By then, the capitalization had fallen to a fraction of the cost of construction. Vanderbilt was able to eliminate his most pressing rival while giving the Central a relief track across the state that was in some places superior to the Central's own four-track line.

In the midst of the great battles between the West Shore and New York Central, Vanderbilt was forced to defend his connections to New England and

# Rate Wars

As this 1857 broadside shows, the Pennsylvania Railroad was a powerful competitor to the New York Central, with direct connections spanning from Manhattan to western cities. *New York State Library.*

Chicago against the Pennsylvania Railroad, which led to additional rate wars. The Pennsylvania itself was an indirect competitor to the New York Central, owning lines that connected New York City to Chicago via Philadelphia, Harrisburg, Pittsburgh and Fort Wayne, Indiana. When the Pennsylvania supported the construction of the West Shore Railroad, he retaliated by first lowering rates and then by taking over the construction of the South Pennsylvania Railroad. This line was anticipated to connect Philadelphia and Reading with Pittsburgh and therefore directly compete with the country's largest and most successful trunk line in its own backyard. The Philadelphia and Reading Railroad, in which Vanderbilt purchased a controlling interest, was a willing participant in such an enterprise, since its line ended at Harrisburg and therefore couldn't deliver anthracite coal to the western states.

The new rate war opened in mid-1881 when Vanderbilt cut rates for grain shipped eastbound from Chicago to New York in half, to fifteen cents per hundred, and then to an unprecedented ten cents. When overall freight traffic failed to increase and the railroads saw their profits dwindle away, rates were gradually restored so that by the following year they were back up to former levels. The restoration did little to repair the financial reports of the previous year: freight traffic decreased by 8.5 percent, while net earnings decreased by 13.25 percent. Overall, net earnings were lower than any year in a decade.

Despite the statistics showing that the rate wars were ineffective, the New York Central and Pennsylvania Railroads took up the fight again that very same winter. Freight trains were reportedly being sent to Colorado as cheaply as to Chicago, and contracts for shipping grain from the Missouri River to New York were closed at prices insufficient to pay the terminal charges. First-class freight rates were lowered from the standard market of seventy-five cents per ton to thirty cents and second-class rates from sixty cents to twenty-five cents. Both railroads suffered losses on every shipment made but refused to submit to arbitration.

Vanderbilt's plan to establish the South Pennsylvania Railroad as a direct competitor to the Pennsylvania Railroad was an effective threat. The proposed route extended west from the Reading's terminus at Harrisburg and traveled through the Clearfield bituminous coalfields to Pittsburgh. The western terminus would connect with the Pittsburgh and Lake Erie, which itself connected with the Lake Shore and Michigan Southern. Thus, the Reading Railroad, already one of the most prosperous lines in the country, would gain a direct outlet for its coal to the west and severely threaten the viability of the Pennsylvania Railroad.

## ...New York Central Lines...

# THE Cheapest Excursion To BUFFALO AND RETURN

## Thursday, October 24, 1901

### ...OVER THE...

# BOSTON & ALBANY
## and New York Central Railroads.

### The Latest Reduction in Rates
#### FROM

| | | | | |
|---|---|---|---|---|
| BOSTON | $7.50 | PALMER | | $5.50 |
| SO. FRAMINGHAM, | 7.00 | SPRINGFIELD | | 5.00 |
| WORCESTER | 6.40 | WESTFIELD | | 5.00 |
| | PITTSFIELD | $5.00 | | |

Tickets will be good in day coaches only; going on train No. 7, leaving South Station, Boston, at 8.30 a.m., or train No. 29, leaving Boston at 6.00 p.m.; returning on any regular train (excepting Lake Shore Limited and Empire State Express) on or before N. Y. C. train No. 12 leaving Buffalo at 9.30 p.m., Tuesday, October 29.

THE PAN-AMERICAN is now at its climax. At no time before have such crowds, such lavish entertainment, and such levity been known. Everybody is at last awakening to the magnificence of this greatest All-American effort, and it is within everybody's reach, now, to enjoy it.

*Get your tickets early as the number is limited, and the Exposition closes on November 1.*

Send for a List of Hotels and Boarding Houses in Buffalo.

A. S. HANSON, Gen'l Pass'r Agt.

RAND AVERY SUPPLY CO., BOSTON.

The rate wars lasted until the beginning of the twentieth century when new federal regulations made it impossible for the railroads to use such tactics as rebates and secret rate adjustments. *New York State Library.*

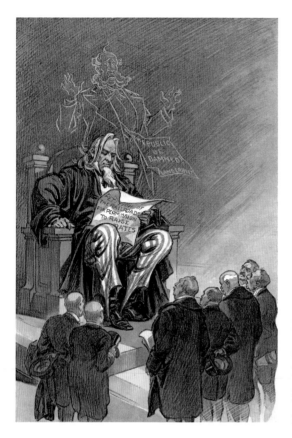

In an editorial cartoon captioned "How Times Have Changed," submissive railroad company executives are shown asking Uncle Sam for permission to raise rates, while the ghost of William Vanderbilt looks on in horror. *Library of Congress.*

The construction of the South Pennsylvania Railroad was often touted as one of the most extreme cases of capital inflating in railroad history. It was reported that a responsible contractor offered to construct it for $6.5 million, but the project was awarded to a "syndicate of Vanderbilt clerks" for $15.0 million. Another syndicate was responsible for raising $40.0 million in mortgage bonds and capital stock. When construction was suspended, it was found that there was a charge of $6 for every $1 actually paid out, the difference going into the pockets of the organizers.

Other trunk lines, such as the Erie and the Baltimore and Ohio, were caught up in the rate wars as they were forced to lower their own rates to remain competitive. This had a domino effect around the country, cutting into the profits of the entire industry. Many large investors and capitalists, including J.P. Morgan, encouraged the two companies to end the hostilities. However, negotiations were hampered by the long-standing bitterness between the two railroad presidents. In addition, Vanderbilt wished to

# Rate Wars

receive a payment that would cover his own investment in construction, while Pennsylvania Railroad managers felt that the building of the South Pennsylvania was an obvious attack without any other business reason and were unwilling to encourage competition elsewhere by paying the price that Vanderbilt demanded.

With help from Morgan as arbitrator, the two railroads finally came to an agreement. The New York Central obtained a lease of the West Shore on a reorganized capitalization of $60 million. The Pennsylvania obtained control of the unfinished South Pennsylvania and the Beech Creek, another line in which Vanderbilt was invested, by the amount of its alleged cost bearing 3 percent interest. Each corporation gained protection of its local traffic, and it was rumored that the two agreed to exercise their influence to shut the Baltimore and Ohio out of New York. To get around Pennsylvania's state statute that a railroad could not purchase, lease or control any competing or parallel line, it was argued that the South Pennsylvania was not a competing line because it was not yet completed.

The panic and subsequent depression of 1893 led to another series of rate wars fought all around the country. It began in New York State when grain rates from Chicago to New York were reduced from twenty-five to fifteen cents. Because rates had to be filed with the Interstate Commerce Commission (created in 1887), and because a new percentage-basis system to intermediate points was in effect, the rate war automatically spread to every intermediate point in the Northeast.

Another round of rate cutting among the trunk lines occurred in 1901 when grain being hauled to Chicago fell to eleven cents per one hundred pounds. Conditions became so bad that the Interstate Commerce Commission filed for injunctions in federal court that prohibited any departure from the published tariffs.

The passage of the Elkins Law imposed severe penalties on those lines that attempted to charge anything but the published rates. This and other federal laws largely curtailed rate wars, instituting price stability for the first time since the end of the Civil War. A test of the new laws came in 1911 when the Delaware and Hudson and the Erie Railroads filed a request to reduce rates to the interior of New York. The other trunk lines displayed solidarity in blocking the request, and with the aid of federal intervention, an open breach of rates was prevented at the last minute. Many within the railroad industry and those it served breathed a sigh of relief that the dreaded rate wars were finally over.

# Hudson River Wars

Of all the mismanaged railroads in the United States during the early 1800s, the worst was likely the New York and Harlem Railroad. It was one of the first railroads to be chartered in the state, operating from New York City to a point south of Albany at Chatham. During its first three decades of existence, the railroad experienced multiple incidents of fraud, complicated lawsuits and an unusual number of severe accidents that brought the company to the brink of bankruptcy.

Although the New York and Harlem was one of the first to be incorporated in the country in 1831, it was built in stages over a period of many years. The first stage of the line north along Fourth Avenue in New York City was completed in 1833. The route to city hall wasn't completed until 1839, while the line to North Plains took another five years. The northern termination of the line was finally completed to Chatham Four Corners in 1852, where it connected to the Albany and West Stockbridge Railroad (later known as the Boston and Albany).

An agreement with the Albany and West Stockbridge gave the railroad trackage rights to Albany, although by that late date, a much shorter route along the Hudson River had already been constructed by another company, so freight shipments were understandably lacking. Other than some iron ore and agricultural products, there were few natural resources along the line to generate any income. It wasn't until 1859 that freight revenues reached $500,000.

This unfortunate situation was exacerbated by its high construction costs—some estimates reaching a total of $1.1 million, or $137,500 per mile.

These figures would have made it the most expensive railroad in the country to build, exceeding even the extravagant costs of the Baltimore and Ohio. Another disadvantage was the restriction from using steam engines south of Fourteenth Street, forcing passengers to disembark and find other means of transportation for the last leg of the journey. Moreover, speeds were limited to a mere five miles per hour over city streets.

While many shortsighted businessmen wrote off the New York and Harlem as a poor railroad with little chance of long-term success, its envious connections inside the nation's largest city gave it a great deal of potential to prosper. It would take a few years for steamboat mogul Cornelius Vanderbilt to see the possibilities himself, but he managed to see them faster than everyone else and would reap substantial benefits by doing so.

Vanderbilt's interest in the Harlem was initiated almost by accident when he was persuaded to invest in a bond issue just as it was about to go bankrupt. During the Civil War, when the railroad's share price had sunk to just a few dollars, Vanderbilt began buying its stock as a long-term investment, a move that many on Wall Street found amusing and foolhardy.

His first great battle against other investors soon followed. In the spring of 1863, businessman Alexander Stewart offered the legislature $2 million for permission to build railroad tracks down Broadway, but his application was rebuffed after strong opposition was voiced by area property owners. George Law, one of the city's wealthiest investors, began to push for a Broadway streetcar franchise a short time later. This would have been a direct threat to the Harlem Railroad's passenger business, which was keeping the company alive. The bill was brought before the state legislature in Albany, a move that dismayed New York City politicians, who felt that the power to govern their own streets would be weakened by the bill's passage.

As an investor in the Harlem Railroad, Vanderbilt asked the Common Council to act on a provision in its charter that allowed the railroad to construct tracks wherever the council permitted. This action would preempt Law's company from laying its own tracks and give Albany a "black eye" in the process. At a meeting of the city's aldermen, the Harlem was awarded the Broadway streetcar franchise even as George Law's company was beginning to break ground. The act gave permission for the Harlem to lay a single track from its Fourth Avenue line starting at a point between Seventeenth and Fifteenth Streets to the corner of Broadway and Fourteenth Street. From there it would lay double-tracks down Broadway to Bowling Green, Whitehall Street and Fulton Street. In return, the company agreed to keep Broadway well paved with Belgian blocks, to refrain from using anything but

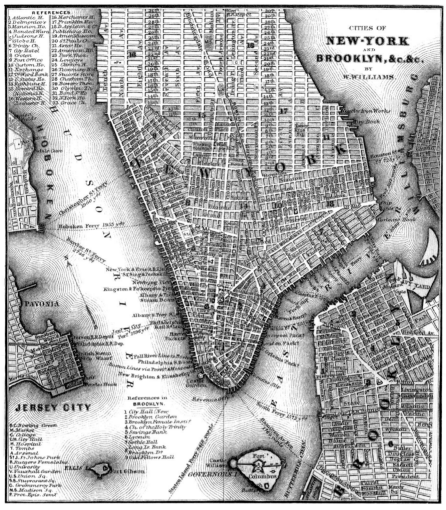

The New York and Harlem Railroad had an enviable route straight down the length of Manhattan via Fourth Street, terminating at Broadway. *Library of Congress.*

horsepower and to pay various rentals and fees totaling $300,000 per year. Mayor Opdyke signed the bill on the ground that it was less evil than the "shameless bill" that was pending approval in Albany.

Little did Vanderbilt or the directors of the Harlem realize that certain members of the Common Council were carrying out a plan to manipulate its stock and profit from the fluctuations in price. The idea was to grant the Broadway franchise and allow the stock to rise. When the price peaked, contracts would be taken out betting that the stock would go down (a so-called short sale).

Then the council would engineer either the cancellation of the Broadway franchise or at least send out a rumor of a revocation at the precise time that its short contracts came due and reap the difference in price as profit.

For a while, the scheme went along as planned. After the bill was signed by the mayor and stock contracts were made, the Common Council passed an ordinance that reconsidered its former decision to grant the Broadway franchise. The stock price began the following day at eighty-three and immediately started falling when orders to sell began to pour in from all quarters. When the Broadway franchise was formally repealed, it caused the stock to drop down to seventy-two. No doubt there were men both inside and outside city hall rubbing their hands together in anticipation of the stock rout that would follow.

Much to the detriment of the council, the scheme reached Vanderbilt's ear some time earlier, allowing him to plan a course of action. In one of his boldest financial moves, Vanderbilt, who had just ascended to the presidency of the Harlem, laid all of his vast wealth on the line and sprang a trap. He began buying every share of Harlem stock that was offered on the market at any price. In effect, he was "cornering" the market, attempting to buy so many shares that when it came time for the short sellers to settle their contracts, there would be no shares left to purchase. The concept of a "corner" was nothing new, but he was carrying it out on a larger scale than ever before. The amount of money involved was so large that it even taxed Vanderbilt's fortune, forcing him to buy stock on credit. The short sellers dumped more and more shares on the market in order to force the price down, but Vanderbilt kept buying. There were only fifty-seven thousand shares to begin with, and he took them all and more. Some of the short sellers resorted to selling borrowed stock rather than incur the loss of buying it outright. Yet the stock price continued to rise, putting further pressure on the short sellers to settle their contracts before going bankrupt. It was an epic struggle of bulls and bears, with one wealthy man on one side against hordes of corrupt politicians on the other.

By the time the short sellers realized what was happening, it was too late to do anything about it. In order to cover their increasingly precarious positions, they had to borrow shares to deliver to their brokers. It turned out that it was Vanderbilt himself who was loaning out these shares, a service for which he charged 2 percent per day. Some of these shares were loaned out and purchased multiple times to squeeze his opponents even tighter. "The chief owners of the Harlem property are Mr. Cornelius Vanderbilt and his immediate friends," reported the *New York Times*. "The public sympathies are wholly with Mr. Vanderbilt in this transaction, and there are the most hearty

> **1857. SUMMER ARRANGEMENT. 1857.**
>
> # Fare $1 Less
> ## THAN BY ANY OTHER ROUTE.
>
> **MORNING LINE FROM WHITEHALL,**
> Lake George and Saratoga,
> TO
> # NEW YORK!
> VIA RENSS. & SARATOGA, ALBANY, VT. & CANADA, AND
> ## HARLEM RAILROAD.
>
> Trains leave **Whitehall at 7 A. M.,**
> **Ft. Edward, 8 "**
> **Saratoga, 8.45 "**
> Arrive at Albany, **10.20 A. M.**
> Leave via Harlem R. R. **11 A. M.**
> Arrive at New York, **5 P. M.**
>
> Making the Shortest, Quickest and Cheapest Route from the above places to N.Y.
>
> Connections by this Route are sure and reliable, as the Harlem Cars wait the arrival of the Trains from Saratoga.
> Baggage Wagons and Passenger Agents are always in readiness to carry Baggage to Harlem Railroad Office, FREE OF CHARGE.
> ☞ Tickets can be procured and Baggage Checked Through at Boston Railroad Office, corner of Maiden Lane and Dean St., Albany.
>
> **W. J. CAMPBELL, Sup't.**

In the years before Cornelius Vanderbilt assumed control, the Harlem Railroad desperately tried to increase passenger traffic on its system through connections with other railroads, but it was never very successful.

congratulations exchanged on the street today that the shameless trick and fraud of the City Council and their stock-jobbing co-conspirators have been paid off with compound interest."

The aldermen involved in the short selling scheme called on Vanderbilt and begged for mercy but received none. Even worse, the entire affair was

# Hudson River Wars

This early photograph of a New York and Harlem train making its way out into the country toward Chatham was taken about the time that Vanderbilt assumed control of the railroad by cornering its stock. *Joseph A. Smith Collection.*

made public and brought additional shame to a city hall already known for corruption. Vanderbilt finally gave his terms for letting his opponents out of their contracts, which included the restoration of the Broadway franchise. He then let the price of the stock go down by putting shares on the market. The *New York Herald* wrote, "It may seem anomalous to outsiders that Harlem stock should rise 30 percent on the repeal of the grant and fall on the repeal of the repeal, but people who sold the stock short understand the reason." Vanderbilt not only increased his control over the railroad but also was able to profit handsomely on the funds he received from loaning out his shares.

Barely a year after Vanderbilt's great victory in his first Harlem corner, a second attempt was made to profit from the railroad, this time by politicians in Albany who apparently had failed to learn any lessons from the misfortunes of their brethren in New York City. In many respects, the scheme mirrored the one of the previous spring. It even involved the very Broadway franchise that was at the center of the last Harlem corner.

Although the Common Council restored Vanderbilt's right to lay tracks on Broadway, he was plagued by various injunctions brought by local citizens who opposed the project, culminating in an order by Judge Hogeboom of the Supreme Court to halt all construction. A measure was introduced to the Senate Committee on Railroads to block the injunction in March. Daniel Drew and Vanderbilt's son-in-law, Horace Clark, representing the Harlem Railroad,

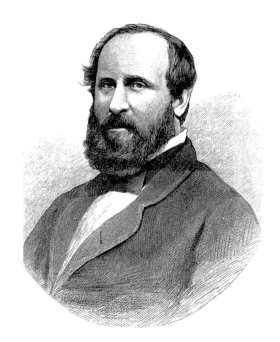

William "Boss" Tweed, the infamous head of Tammany Hall, often collaborated with Daniel Drew and Jay Gould to profit from insider knowledge of the stock market, even becoming a director in the Erie Railway.

spoke in favor of the bill, while Judge Hilton, who was aligned with Alexander Stewart, opposed it and renewed Stewart's offer of $2 million for the franchise.

To some it would seem odd that Drew would lobby in favor of such a bill. He had recently become treasurer of the Erie Railway and was greatly profiting from his position by manipulating the stock price. The Harlem Railroad did not interchange with the Erie, so his intervention appeared to be a mystery. As was usually the case, however, Drew had an ulterior motive. William "Boss" Tweed of Tammany Hall was an associate of Drew's and participated in some of these stock manipulations. During one of these schemes, Tweed lost a substantial amount of money and angrily called on Drew at his home to help him recoup his money. Drew proposed to bring him in on a plan to profit from a stock manipulation of the Harlem Railroad and Vanderbilt himself. Although Tweed was never personally harmed by Vanderbilt, he had no compunction against taking some of the Commodore's money.

Drew, along with Tweed and members of the Albany political machine, gave the impression that the bill would be passed and that Vanderbilt would finally be able to have his Broadway extension. The price of Harlem stock rose accordingly, reaching 149 the day after the rumor was circulated among financial circles. Drew and his partners immediately sold the stock short in large quantities, knowing that the Senate Committee was going to meet the next day. When the announcement came that the committee reported unfavorably on the bill, the effect on Harlem

stock was immediate, dropping to 101. Senator Dutcher publicly warned that those who opposed the measure were on Wall Street "betting great odds" that it would be reported unfavorably, but no one listened.

These dealings were discovered by Vanderbilt before the public got wind of it, and he once again took decisive action. The bear movement was even larger than the first one, so he enlisted the help of John Tobin, a wealthy speculator and former gatekeeper on Vanderbilt's Staten Island Ferry. Tobin made a few lucky speculations on Wall Street, including a partnership with Vanderbilt on the first Harlem corner, and was reportedly worth about $3 million. Shortly after Harlem stock began declining, Vanderbilt sent for Tobin and asked whether he was hurt by the fall in the share price. Tobin replied that he had not panicked and sold out and that all his stock was paid for and locked up in his safe while he waited for the price to rise again. Then Vanderbilt asked him whether he thought "those fellows" in the legislature ought to "get a dressing" for the way they went back on them. Tobin agreed to put up $1 million for the venture, and the two set to work arranging their latest campaign against the bears. They enlisted one more Wall Street powerhouse, Leonard Jerome, who put up $5 million of his own money.

At Vanderbilt's signal, Jerome and Tobin began buying blocks of Harlem stock at constantly increasing prices. Before the outside world knew what was happening, the three men pushed the price above 150. The legislators, Drew and others were so confident of their plan that they continued to buy short contracts on the same shares until it was too late to cut their losses. Vanderbilt soon managed to purchase or hold contracts for twenty-seven thousand shares more than had ever been issued. With no stock left on the market, the price rose to 152 at the end of March and to 205 on April 20.

As the stock price continued to climb, Drew and company knew that they were beaten. To rub salt in their wounds, the *New York Herald* reported that a bill was authorized on behalf of the Harlem Railroad to increase its capital stock by $3 million in order to complete its double-tracking project, and it permitted Harlem bondholders to convert their bonds into stock.

The latest announcement sent the stock price to 220, causing a near panic among the short sellers. The *Herald* almost gleefully noted, "The bears of the lobby have met their match—in defeating Harlem they imagined they had a monster operation in selling Harlem short, and thus ran afoul of Commodore Vanderbilt, and have met with a heavy loss." It went on to state that the bears consisted principally of Daniel Drew, Erastus Corning Jr., A.G. Jerome and Company and Thurlow Weed, the Republican leader, who together lost $3 million.

The Harlem corner was nearly upset by the so-called Chase Panic in April when the price of gold plummeted, taking many stocks down with it. Rock Island Railroad stock fell from 149 to 100 in two hours while the Fort Wayne dropped from 159 to 75. Vanderbilt called a meeting of the Harlem group and told them that he was afraid they would not be able to sustain the corner in the face of the market selloff. Tobin, however, reassured him that the panic would be a temporary one, and he proved to be right.

The stock market recovered in early May, as did the share price of the Harlem. In desperation, Drew tried one more trick. An anonymous letter was circulated around Wall Street that praised the former president of the Harlem, Allan Campbell, who was replaced by Vanderbilt the previous year, and attacked the current leadership. Despite the almost comical mismanagement of the railroad in preceding years, the letter stated that the new managers "displaced some of the ablest directors that ever adorned the councils of any railroad board, and put in their stead brokers and stock speculators who have been engaged in cornering the company's stock."

Such hypocritical statements were laughed at by the general public and had no affect whatsoever on the stock price, which reached 275 on May 14. Three days later, Vanderbilt was reelected as president while the bears tried to settle their contracts as best they could, some having to pay as high as 285 per share. "We busted the whole legislature," Vanderbilt later gloated, "and scores of the honorable members had to go home without paying their board bills."

Among those caught in the short sale included "Boss" Tweed, who was understandably upset at Daniel Drew for bringing him in on another losing venture. However, Drew himself suffered perhaps the worst losses. With his tail between his legs, he went up to Vanderbilt's office on Fourth Street and begged for mercy, with little result. "Drew," said Vanderbilt, "never sell what you haven't got. And don't put it in any man's hand to ruin you. Bye-bye." Drew went away but came back a few days later. Warning Vanderbilt that he couldn't possibly cover his contracts, he related how Tweed also lost heavily in the Harlem speculation. Since Tweed was street commissioner of New York, with vast influence in city politics, Vanderbilt relented somewhat, knowing that he may need Tweed's assistance in the future. He agreed to let Drew out of his contracts for $500,000 in cash.

Smarting from their humiliating losses, neither the Common Council in New York nor the legislature in Albany were expected to award Vanderbilt the Broadway franchise anytime soon. In fact, the bill was never again revived, and in 1866, the city aldermen ordered that the tracks already laid be removed.

# Hudson River Wars

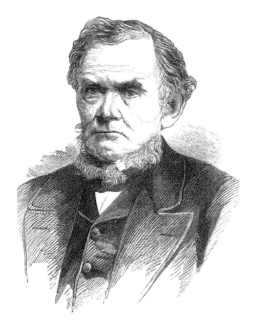

"Uncle" Daniel Drew (1797–1879) lost his first stock market battle with Cornelius Vanderbilt during the Harlem stock corner, but he would get his revenge during the Great Erie War.

The result of this first in a string of battles played out on Wall Street gave Vanderbilt a substantial profit on the shares he sold back to the short sellers (probably in the hundreds of thousands of dollars) and an increased share of ownership of the Harlem from the shares he kept (from a one-tenth ownership to about one-third). Within a comparatively short time, Vanderbilt applied the business tactics he used on his steamboats to the railroading world—substituting waste for economy, delays in the schedule for regularity and confusion for order. Residents and shippers along the line perceived the improvements, consequently increasing the business and profitability of the road. One of Vanderbilt's pet projects was getting rid of an annoying bottleneck at Murray Hill, where horses had to be hitched to the cars to climb the hill, by tunneling under it. Steam engines could then run all the way down to the depot at Fourth Avenue for the first time. This and other improvements had the desired effect. Much to the astonishment of doubters, the stock began paying steady dividends.

Even as the New York and Harlem Railroad was inching its way toward Chatham, businessmen who were brave enough to go up against the steamboat interests were laying the groundwork for a new railroad along the banks of the Hudson River. In 1842, a survey was made beginning where the Harlem railroad crossed the Harlem River, north along the river for thirteen miles to Spuyten Duyvil, forty-seven miles along the riverbank to Fishkill Landing, and north to Poughkeepsie. As expected, opposition from both the steamboat

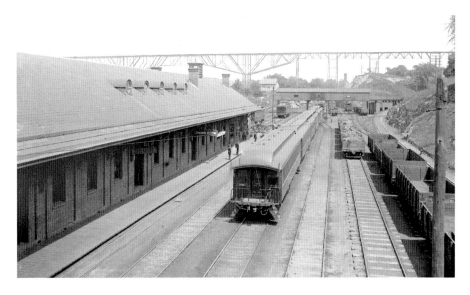

The city of Poughkeepsie became an important midpoint between Albany and New York City on the Hudson River Railroad. In the background is the Central New England Railway's "high bridge" across the Hudson on its way to Maybrook. Its construction was opposed by Cornelius Vanderbilt, concerned that it would draw traffic away from his railroad. *Library of Congress.*

lines and the New York and Harlem rose up against the proposed railroad and managed to stymie efforts to begin construction for several years. The tide of progress was with the Hudson River Railroad, however, and in 1846, the legislature passed an act allowing for the railroad to incorporate.

It soon became apparent to Vanderbilt that presiding over the Harlem Railroad while having no influence on the Hudson River Railroad was unsustainable in the long term, even with the former line's linkages deep in the heart of New York City. The Hudson River road was much more efficient at moving freight to and from the city due to its nearly gradeless line, shorter route and direct connection with Albany. Therefore, he began buying shares of the Hudson River a short time after he took full control of the Harlem. In the summer of 1863, the stock price was at 123 after a bear campaign by various speculators had forced the price downward. Vanderbilt took advantage of the low price and began buying shares even as the Harlem war was at its peak.

Showing surprising finesse for someone who was relatively new to the stock market, Vanderbilt devised a scheme that some analysts said had no superior in the records of speculative ingenuity. He instructed his brokers to approach

several "bear" houses (groups of investors who usually bet on stocks going down) and ask them to purchase his stock at 123 for cash and then sell it back to him on buyers' options that would run for periods of twenty to thirty days. The "bears" figured that Vanderbilt was making the offer because he was short of cash and would therefore be able to get a better price once it inevitably declined. They cheerfully entered into contracts involving tens of thousands of shares.

Unfortunately for them, just two weeks later, the *New York Times* reported a favorable earnings season for the Hudson River Railroad, sending the stock price to 155. With the sellers' options falling due on fifty thousand short sales, the bears started growing concerned. Then, without warning, Vanderbilt called the stock that he was contracted to buy. When the bears realized that they were expected to deliver the stock immediately at a price far lower than the current market price, panic ensued. To make matters worse, the bears were contracted to turn over shares that they didn't have and could not obtain, since Vanderbilt and others had purchased most of those that were available. He finally relented and loaned out the shares needed to cover the contracts. "Wall Street has never known such a successful corner," reported the *New York Herald*. "The regular bears of the Board—the men who have been accustomed to 'hammer' other men's property as a playful diversion—are suffering severely." The corner ended when all contracts were settled at a stock price of 179. Vanderbilt came away from the Hudson River corner with appreciably more stock in the railroad than when he started, and he and his supporters realized more than $2.5 million in profits.

In addition to the speculations on its stock, Hudson River Railroad officers had to deal with competitors in the form of boats that plied the Hudson River. Even at that late date, shipping bulk goods by steamboat was actually cheaper than by rail on a deep and unobstructed water lane like the Hudson. The New York Central took advantage of these lower rates during the summer and was therefore able to engage in rate wars with other trunk lines such as the Erie Railway. In the winter, when the Hudson froze over, the Central was forced to feed its freight shipments to the Hudson River Railroad.

This arrangement caused a great deal of frustration to the railroad's president, John Tobin. Railroads were burdened with high fixed costs in comparison to boat lines, including the costs of maintaining tracks, structures and equipment and keeping employees on the payroll whether trains were running or not. These alone represented two-thirds of all expenses. Tobin saw his railroad nearly grind to a halt every spring as the river ice melted away while expenses kept right on flowing. One official wrote, "It is unjust to

insist that the Hudson River railroad should form part of the Central's trunk line during three months of the year and be excluded during nine months of the year."

The situation was especially egregious before the railroad bridge was built over the Hudson in 1866. All freight brought from the west had to be unloaded at the riverfront at Albany, so it was tempting to merely load it onto the cheaper steamboats than to ferry it across the river to East Albany and load up cars of the Hudson River Railroad for the rest of the trip downstate.

Although the Hudson River Railroad was far smaller than the nation's four trunk lines, it was still a significant entity in its own right. The line spanned 144 miles in length and by the end of the Civil War possessed 67 locomotives, 29 baggage cars, 130 passenger cars and 671 freight cars. It annually carried more than 2 million passengers and 600,000 tons of freight. President Tobin rightly believed that the railroad should be compensated for the lack of business in fair-weather months by getting higher local rates on through freight during the winter.

Vanderbilt was already in a good position on the Hudson River board. After he acquired a large share of its stock, he lobbied to have five Harlem directors appointed to the board. At the ensuing election in June 1864, John Tobin was elected president with Vanderbilt's backing. After the election, some of the directors became dissatisfied with the growing influence of the "Harlem clique" and resigned their positions. Vanderbilt himself was elected to one of these vacated positions, while his allies from the Harlem were elected to the rest.

Tobin's demand for higher rates during the winter of 1865 came at a bad time for the Central, which was in the middle of another rate war with the Erie Railway. Any increase in rates paid to the Hudson River would undermine its ability to compete with the other trunk lines. The president of the Central, Dean Richmond, asked Vanderbilt to intervene and persuade Tobin to drop his demands. After intense negotiations, Tobin backed down. In return, Vanderbilt forced Richmond to agree that when the spring arrived the two railroads would make a permanent arrangement for the shipment of freight year round.

On the surface, Vanderbilt intervened merely to avoid confrontation with the New York Central, and that may indeed have been his only intention. However, the deal resulted in a loss of confidence with John Tobin by the board of directors. Tobin stepped down as president that summer, and the board elected Vanderbilt as president and his son William as vice-president. Since both the Harlem and the Hudson River Railroads were controlled by

## HUDSON RIVER RAILROAD.

### NEW-YORK TO AND FROM
## ALBANY & TROY

### REDUCTION OF FARE.

*On and after* MONDAY, APRIL 26th, *the Trains will run as follows:*

### GOING NORTH,

Leave New-York, from the office, cor. Chambers St. and College Place, at

- **6 A.M.** EXPRESS TRAIN FOR ALBANY AND TROY, connecting with Western Train, stopping only at Peekskill, Fishkill, Po'keepsie, Rhinebeck, and Hudson. Through in 4 hours from 31st Street. **Fare, to Albany $2.50, to Troy, $2.60.**
- **7 A.M.** WAY MAIL TRAIN FOR ALBANY AND TROY, stopping at all Way Stations. **Fare to Albany, $2.00, to Troy, $2.08.**
- **8 A.M.** To PEEKSKILL, stopping at all Way Stations.
- **9 A.M.** WAY TRAIN TO ALBANY AND TROY, stopping at Dobbs' Ferry, Sing Sing, Peekskill, Cold Spring, Fishkill, New Hamburgh, Poughkeepsie, Hyde Park, Rhinebeck, Barrytown, Oakhill, Hudson and Stuyvesant. **Fare, to Albany $2.00, to Troy $2.08.**
- **11½ A.M.** To PEEKSKILL, stopping at all Stations.
- **1 P.M.** WAY TRAIN FOR ALBANY AND TROY, stopping at Yonkers, Tarrytown, Peekskill, Cold Spring, Fishkill, New Hamburgh, Poughkeepsie, Rhinebeck, Tivoli, Oakhill, Hudson, and Coxsackie. **Fare, to Albany $2.00, to Troy $2.08.**
- **4 P.M.** WAY TRAIN TO ALBANY AND TROY, stopping at Manhattan, Yonkers, Dobbs' Ferry, Dearman, Tarrytown, Sing Sing, Crugers, Peekskill, Garrisons, Cold Spring, Fishkill, New Hambugh, Po'keepsie, and all Stations north, on signal. **Fare, to Albany $2.00, to Troy, $2.08.**
- **5 P.M.** To POUGHKEEPSIE, stopping at all Way Stations.
- **6 P.M.** EXPRESS TRAIN FOR ALBANY AND TROY, stopping only at Peekskill, Po'keepsie, and Hudson. Through in 4 hours from 31st Street, and connecting with Western Trains. **Fare, to Albany, $2.50, to Troy, $2.60.**
- **6¼ P.M.** To TARRYTOWN, stopping at all Way Stations.
- **7½ P.M.** ACCOMMODATION TRAIN FOR ALBANY AND TROY, stopping at all Way Stations. **Fare, $1.25.**

**Hudson to Albany,** leave Hudson at 8.05, A.M., stopping at all Way Stations.

### GOING SOUTH.

| LEAVE TROY ENGINE STATION | LEAVE ALBANY AT | |
|---|---|---|
| 5.45 A.M. | 6 A.M. | WAY MAIL TRAIN FOR NEW-YORK, stopping at all Stations where there are Mails to be received and delivered. **Fare from Albany, $2.00, from Troy, $2.08.** |
| 6.45 A.M. | 7 A.M. | EXPRESS TRAIN FOR NEW-YORK, stopping only at Hudson, Rhinebeck, Po'keepsie, Fishkill, and Peekskill. Thro' in 4 hours. **Fare, $2.50 from Albany, $2.60 from Troy.** |
| 10.45 A.M. | 11 A.M. | WAY TRAIN, stopping at Stuyvesant, Hudson, Oakhill, Tivoli, Barrytown, Rhinebeck, Hyde Park, Po'keepsie, Fishkill, Cold Spring, Peekskill, Sing Sing, and Dobbs' Ferry. **Fare, $2.00 from Albany, $2.08 from Troy.** |
| | 11½ A.M. | THROUGH AND WAY FREIGHT only, from East Albany. |
| 12.30 P.M. | 1½ P.M. | FOR HUDSON ONLY, stopping at all Way Stations. |
| 3.20 P.M. | 4 P.M. | WAY TRAIN, stopping at Stuyvesant, Hudson, Oakhill, Tivoli, Barrytown, Rhinebeck, Hyde Park, Po'keepsie, New Hamburgh, Fishkill, Cold Spring, Peekskill, Tarrytown, and Yonkers. **Fare from Albany, $2.00, from Troy, $2.08** |
| 6 P.M. | 6¼ P.M. | EXPRESS TRAIN, stopping only at Hudson, Rhinebeck, Po'keepsie, and Peekskill. Through in 4 hours. **Fare from Albany, $2.50, from Troy, $2.60.** |
| 8.30 P.M. | 8¾ P.M. | NIGHT MAIL TRAIN, stopping at all Stations on signal. **Fare $1.25.** |

**Leave Poughkeepsie for New-York,** at 6¼ A.M., stopping at all Stations above Peekskill, and at Crugers, Sing Sing, Tarrytown, Dearman, Dobbs' Ferry, Yonkers, and Manhattan.
**Leave Peekskill for New-York,** at 6½ A.M. and 4 P.M., stopping at all Way Stations.
**Leave Tarrytown for New-York,** at 6½ A.M., stopping at all Way Stations.

☞ Passengers will procure Tickets before entering the Cars.

*New-York, April 26th, 1852.*      E. FRENCH, *Superintendent.*

Despite its advantage of having a direct connection into the heart of New York City, competition from steamboats kept the Hudson River Railroad from earning a profit until it was merged with the New York Central.

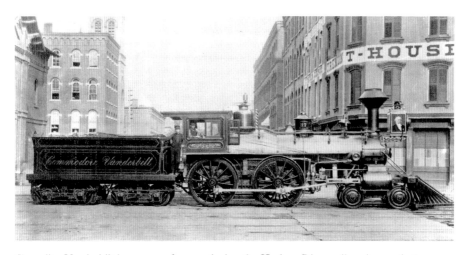

Cornelius Vanderbilt became so famous during the Hudson River railroad wars that a steam locomotive from an Upstate railroad was named after him. The Commodore Vanderbilt was the first coal-burning locomotive to run on the Rensselaer and Saratoga Railroad and served from 1871 to 1905. The engine reportedly carried a picture of the Commodore on its front headlight. *Joseph A. Smith Collection.*

Vanderbilt, an agreement was naturally signed to end all competition between the two companies. Under the agreement, the Hudson River paid the Harlem $10,000 per month in return for cooperation in setting rates, although this could have simply been a way to subsidize the weaker railroad.

As he did with the Harlem Railroad, Vanderbilt set about improving the Hudson River through efficiency and economy. Harlem Railroad trains ceased running into the Boston and Albany depot at East Albany and instead began using the Hudson River's depot. The tracks were upgraded, the motive power was increased to seventy-five engines and a substantial dividend was placed on the stock, causing the share price to climb higher than ever before. Combined freight and passenger revenues rose by $300,000 the following year.

Vanderbilt's takeover of the Hudson River Railroad eventually led to the largest and final war on the Hudson River. Managers of the New York Central were not pleased to see the control of its two principal rail connections with New York City pass into the hands of one man—a man who was wealthy, powerful and not easily intimidated. Whereas formerly the two railroads were forced to submit to the influence of the New York Central, afterward the two worked in harmony to dictate prices and policies to the larger road. A war between the two systems was almost inevitable.

# The New York Central War

The New York Central had a long and at times difficult history before Cornelius Vanderbilt came onto the railroad scene. Certainly when the Mohawk and Hudson Railroad first opened for business in 1832, there were those who envisioned a continuous line from Albany to Buffalo, but that dream would take decades to be realized. As long as the Erie Canal operated at a profit for New York, there was no incentive for legislators to grant any one company a charter to build a railroad that paralleled it across the entire state. Instead, small railroad franchises were granted over a period of years that operated as completely separate entities.

The success of the Mohawk and Hudson all but ended the public hostility against railroads in New York. Cities witnessed the advantages conferred upon Albany and Schenectady and began an intense period of railroad planning and construction in the years that followed. The second and third railroads in the state connected Schenectady with Saratoga and Troy with Ballston Spa to serve the tourist centers and begin the process of connecting New York with Canada.

The second railroad that would eventually become part of the New York Central was the Utica and Schenectady, which began running in 1836 despite intense opposition from canal interests. It operated at a sizeable profit even with the tough restrictions imposed on it in the charter, thus encouraging others to follow suit.

The Syracuse and Utica received somewhat better terms from the legislature in that it was allowed to carry freight as well as passengers, even if it had to pay

tolls to the state during the months that the canal was open. Construction of the Auburn and Syracuse was stymied by the Panic of 1837, but it was saved from abandonment by a $200,000 loan from the legislature thanks to the political power residing in Auburn, which was bypassed by the Erie Canal.

The Auburn and Rochester, at seventy miles, was one of the longer railroads that eventually made up the Central. Like the Auburn and Syracuse, it was built to serve areas that did not benefit from the Erie Canal, so it was able to carry freight from the outset. When completed in 1841, the line ran from Auburn through Seneca Falls, Waterloo, Geneva, Manchester and Canandaigua to Rochester.

The city of Rochester had big plans for the Tonawanda Railroad, envisioning a day when it would reach all the way to Buffalo. However, the farthest it reached was Attica via Batavia. The Attica and Buffalo Railroad, opened in 1842, seemed to complete the chain of railroads between Albany and Buffalo. However, businesses in Rochester caused the terminuses of the Tonawanda and the Attica and Buffalo to end at either side of the city so that passengers would have to leave one train and hire a conveyance and porters to catch another train.

The seven lines mentioned here formed the nucleus of what would become the New York Central, although several branch lines, such as the Schenectady and Troy and the Lockport and Niagara Falls Railroads, would also become part of the system. A miniature war was fought over a proposed line called the Mohawk Valley, which would have served towns on the south side of the Mohawk River that were bypassed by the Utica and Schenectady. As a result of what was perceived as preferential treatment of Albany by the Utica and Schenectady Railroad, capitalists in the city of Troy attempted to get control of the project and eventually build a competing line all the way to Buffalo. The powers that were running the profitable Utica and Schenectady saw this as a direct attempt to draw business away from them, so they filed a protest. The two contending lines bombarded the legislature with various lobbying tactics. Thanks to Erastus Corning's connections, however, the Utica and Schenectady won the fight, and the Mohawk Valley project was never started.

Most of the operators of the small lines across the Mohawk Valley were content to continue doing business as they had for more than a decade. However, two more trunk lines were in the final stages of completion, the New York and Erie and the Pennsylvania, and both were capable of drawing traffic away from the inefficient Mohawk lines. Citizens of Rochester, Syracuse, Utica and Albany grew increasingly concerned that if their

railroads were not united into one system, the Mohawk Valley corridor would eventually decline and become a second-class transportation route.

An early attempt to consolidate was delayed by resistance from the Schenectady and Troy Railroad. The Troy press continued to complain about the amount of traffic coming in from the West that was diverted to Albany over the Mohawk and Hudson Railroad rather than to Troy over the Schenectady and Troy Railroad. The fact that Troy possessed a bridge over the Hudson River to make rail crossings easier while Albany did not provided further argument for using the Troy route. However, Albany's power in the legislature kept most trains running to Albany. The people of Troy felt that if the small lines were merged into one, their situation would only worsen. Eventually, the objections were overcome with agreements to send a certain percentage of trains to Troy.

Even the Erie Canal interests gave up the fight as their position weakened in the face of new technology. After intensive lobbying by Erastus Corning and others, a measure passed the legislature in 1851 authorizing "two or more companies" on the line between Albany and Buffalo to consolidate their stock and become one company. After two more years of legislative fine-tuning and negotiations among the ten railroads, the merger finally took place on July 6, 1853. Upon its formation, the New York Central became the largest corporation in existence, with a capitalization of $23 million. Erastus Corning, who at age fifty-three was at the height of his financial and political power, was named the first president.

The history of the New York Central during the Corning years was largely uneventful. The biggest scandal revealed that in lieu of a salary, Corning profited from his position by feeding contracts to his iron and steel factories. He also had a silent agreement with several large stockholders stipulating that in return for their votes he would guarantee the payment of a dividend whether the railroad was making money or not. For more than a decade, Corning enjoyed free rein as thousands of blank, signed proxies were delivered to him at each stockholders' meeting. Despite the controversy these practices generated in the press, they were child's play compared to the stock manipulations, taxpayer swindles and treasury plundering that took place on other railroads. Looking back, Corning is now considered to be one of the more honest and effective "railroad kings" of the day.

Corning's ultimate downfall stemmed from the lack of a direct rail connection between Albany and New York City. The Hudson River Railroad was both willing and able to provide that link, but Corning preferred to use the steamboat lines that plied the Hudson during navigation season.

The steamboat General Washington, the largest in the world when it was built in 1852, was designed specifically to compete against "the Hudson River Railroad and all other competition." It was able to transport three thousand passengers at an average speed of thirty miles per hour. *Library of Congress.*

Members of the so-called Albany Regency (longtime members of the Democratic Party machine) had a financial stake in the steamboat lines, so Corning was reluctant to give business to the Hudson road. The steamboats were even able to ship freight at slightly lower rates than the railroad, even if they were slower at getting to New York Harbor.

As long as there were pliable managers at the Hudson River Railroad, the Central could continue to send freight by water during the summer and by rail during the winter. The situation changed when Cornelius Vanderbilt obtained stock ownership of the Hudson road and decided that he was not going to let the Central dictate shipping policy to his railroad anymore.

The construction of a new bridge over the Hudson River at Albany in February 1866 set the stage for the last and most decisive war between the Hudson Valley railroads. For many years, there was an inconvenient bottleneck at Albany due to a lack of a bridge there. Freight and passengers from the west had to be unloaded at the water's edge for either a ferry across the river to catch a Hudson River Railroad train or to board a steamboat for the journey south to New York. Passengers heading from New York to the north had the option of leaving the train at East Albany or continuing north to Troy. The latter city possessed a bridge over the Hudson since 1835, when the Rensselaer and Saratoga Railroad was built from Troy to Ballston Spa, which many believed would give Troy a decisive edge over Albany. However, as the New York Central was based in Albany, most freight and passengers never made it to Troy, and so the bottleneck persisted. The merchants and laborers who depended on this bottleneck for employment (it was labor-intensive to unload and

load freight cars) were finally overruled, and the new Albany bridge was finally built.

Once the bridge was completed, Vanderbilt fully expected the New York Central to give up its long-standing policy of transferring freight to steamboats now that cars did not have to stop to be unloaded for a river crossing. However, when spring arrived and the river thawed out once again, the Central continued with its policy of breaking bulk at Albany and shipping freight on the People's Line boats, despite the promises that Dean Richmond personally made to Vanderbilt. To make matters worse, the Central had a galling policy of receiving freight cars from the Hudson River Railroad, delivering them to freight depots in the West and delivering them back empty. This forced the Hudson road to haul empty cars back to Manhattan at a pure loss.

When Vanderbilt attempted to carry out reprisals against the Central, it retaliated by completing the Saratoga and Hudson River Railroad and using it to bypass the Hudson River Railroad. This was particularly irritating to Vanderbilt since he had been persuaded by Daniel Drew a few years earlier to support such a project. The little railroad would operate from a point south of Schenectady to Athens on the west side of the Hudson River. The idea made sense when Vanderbilt was a steamboat operator—the port at Athens was located farther south than Albany and therefore took longer to freeze in the winter, which extended the steamboat season. Once Vanderbilt became owner of the Hudson River Railroad, the little rail line he helped create became a thorn in his side. Once it was completed in the spring of 1866, the Central used it to bypass parts of Vanderbilt's railroad and sometimes returned empty Hudson River freight cars to Athens. The so-called Athens Branch was merged with the New York Central the following year.

In June, Daniel Drew abruptly called off the battle between his boat line and the Hudson River Railroad. Runners from his company who were normally employed to stake out railroad stations and call out the steamboats' cheaper fares were called away, and the boat connection at Athens Junction was discontinued.

These actions coincided with several financial transactions carried out by Drew at the Erie Railway, of which Vanderbilt was a significant shareholder. The railroad was suffering a cash shortfall and needed to borrow money. Drew (the railroad's treasurer) arranged a personal loan in exchange for Erie securities as collateral, consisting of twenty-eight thousand unissued shares and $3 million in bonds that could be converted to stock. After writing a

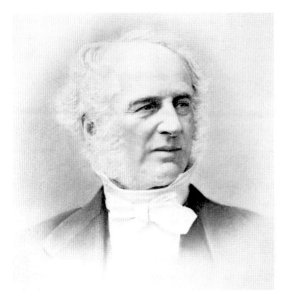

Cornelius "Commodore" Vanderbilt (1794–1877) began his railroad career in a stunning fashion—obtaining control of the only railroad that had access to the streets of Manhattan by cornering the company's stock two years in a row. He then followed up by taking control of the Hudson River and New York Central Railroads in short order. *Library of Congress.*

check to the Erie for $3.5 million, he sold large blocks of stock at ninety. He then converted his bonds to stock and flooded the market with sixty thousand shares all at once. Thanks to the law of supply and demand, the share price immediately dropped to fifty-seven, causing stockholders to sell off in a panic and enabling Drew to buy back his collateral at a far lower price than he sold it. All of these maneuverings had to take place without the intervention of Vanderbilt, who was wealthy enough to turn the tables on Drew. It is speculated that the "truce" on the river was Vanderbilt's reward for leaving Erie stock alone.

Despite the so-called truce and verbal agreements between the railroads, William Vanderbilt reported to his father that there were "hundreds of instances" in which freight that was specifically earmarked for the Hudson River Railroad was redirected to the People's Line throughout the summer. Richmond threw Vanderbilt a bone by agreeing to shut down the Athens Branch so that no more freight cars would be delivered to the People's Line at that point. Vanderbilt must have felt some relief that this so-called white elephant railroad was out of the picture.

The relationship between the Central and the Hudson River was not ideal, but at least Richmond and Vanderbilt respected each other and could reach an agreement that enabled the Hudson River to turn a profit, albeit smaller than Vanderbilt would have liked. This situation would change dramatically that autumn.

# The New York Central War

The American Express Company, founded by William Fargo, utilized runners called express messengers to transport high-priority items and cash by railroad. The company would pay the railroads to allow their messengers to ride in the baggage cars of trains. In some instances, American Express secured these agreements without payments by giving railroad presidents shares of stock that were not publicly traded. Since Vanderbilt was so wealthy, bribery had no effect on him. Instead, he demanded that American Express pay ever higher rents to both the Hudson River and Harlem Railroads. This infuriated Fargo, who secretly began buying shares of the Central in order to stage a coup in the December elections and remove any Vanderbilt supporters from the board of directors, including Richmond. Through his many connections on Wall Street, Vanderbilt got wind of the coup plot but decided not to act. He even sold his remaining shares of Central stock, declaring, "I will not own any of this property where it is owned by such a set of men [as Fargo and his partners]."

The situation took a grave turn in August when Dean Richmond unexpectedly passed away from a short illness. This came at a crucial time for Vanderbilt, who was trying to negotiate with the Central yet again for favorable terms. In October, he sent William to Albany to meet with the Central's board. The dispute was unchanged: Vanderbilt wanted the Hudson River to have the Central's freight business year round, while the Central wanted to use the People's Line during the summer. Someone suggested that William set a price for his father's cooperation in using the steamboats for part of the year. Although he was not authorized to make such a deal, he threw out a figure of $100,000 per year. The Central's board immediately accepted.

When Vanderbilt heard of the deal, he objected to his son that $100,000 was not nearly enough to pay for his freight trains to be idled during boat season. William later recalled that "there has never been any one act in my life that has so much met with the disapprobation of Cornelius Vanderbilt as that act." Vanderbilt fumed, "We would a great deal rather do the business [of hauling freight] than to get the money and not do the business." But he accepted his son's authority to make the deal, however much he was opposed to it.

Had the Central simply paid the amount agreed to, the uneasy alliance between the two railroads may have lasted for years. However, a man named Henry Keep, a wealthy Wall Street trader allied with William Fargo, actively purchased Central shares to aid Fargo in his coup attempt. He even traveled to Europe and obtained vote proxies from shareholders in London. When he arrived back home in November, he visited Vanderbilt and delivered the

Beginning in 1866, Cornelius Vanderbilt's son William (1821–1885) was given increasing responsibilities on the Hudson River and Harlem Railroads, such as the unenviable task of trying to negotiate with the New York Central Board of Directors for better freight transfer terms. *Library of Congress.*

The long overdue construction of a bridge at Albany connecting the New York Central with the Hudson River Railroads led to a war between the two lines that ultimately resulted in Cornelius Vanderbilt's greatest victory.

stunning news that he and Fargo intended to take over the board of directors. Furthermore, he had no intention of honoring the $100,000 agreement that was just ratified by the two railroads.

At the annual meeting, it was discovered that Keep and Fargo were just a part of an overall strategy by New York City–based investors to take control

of the Central and effect a complete change in management. Thirty-five men held $16 million worth of stock and traveled to Albany to personally vote with it. In the end, the so-called New York ticket voted 175,000 shares out of a total of 189,000. The old "Albany Regency" was swept away for good, along with Vanderbilt's allies. Keep was elected president, and Fargo was made vice-president. The following week, the agreement with the Hudson River Railroad was revoked.

Despite his rage, Vanderbilt attempted to come to some agreement with the new leadership. He and William met with Keep and others in Manhattan, but five hours of intense discussions failed to help matters. In January, William was informed by the Central's treasurer that payment of the Hudson River Railroad's terminal charges would no longer be forthcoming despite a separate agreement. During another meeting, William asked that for every carload of freight sent west over the Hudson River or Harlem Railroads, the Central should send one carload south from Albany to New York. Keep rejected the proposal, reasoning that the Central was twice as long as either of Vanderbilt's railroads and therefore would be entitled to send two loads for every one received at Albany, or that the tolls be divided pro rata.

It was apparent that the Central's board was not only going to continue with its former freight policies but would also be openly hostile to Vanderbilt going forward. In addition, Vanderbilt learned that Fargo and Keep were selling Central stock short in an effort to profit from the revocation of the Hudson River Railroad contract.

Backed into a corner, the boards of the Hudson River and Harlem Railroads voted to suspend all relations with the New York Central as of January 18. No freight from the West would be accepted. Hudson River trains would halt at East Albany, forcing passengers to cross the new Albany bridge on foot and purchase separate tickets for the remainder of the trip to New York.

Mother nature was on Vanderbilt's side in his final battle with the Central. Temperatures plummeted even as the blockade went into effect, forcing all boats off the river for the remainder of the season. Crossing the bridge on foot was difficult, made doubly so if a porter wasn't found to carry one's baggage. Women suffered the most in their fashions of the day, and as so often happens in critical situations, there was an unusual shortage of sleighs available to carry people across the river. Freight immediately began piling up in Albany, while an outcry arose from New York City that it was cut off from the rest of the state, indeed from the rest of the country.

Recognizing their miscalculation, the Central's board asked for a meeting with Vanderbilt, who reacted to the request with scorn. Rather than agree to a meeting, he made a show of playing card games with his friends at the Manhattan Club as an immense blizzard blanketed the region. Dismayed passengers were forced to trudge through the bitter cold and snowdrifts from Albany to East Albany while freight continued to fill every available warehouse. The Central appealed to the Pennsylvania and Erie railroads to accept its freight, but both had to use ferries to get into New York and would not be able to handle the additional tonnage. An agreement was quickly made with the Housatonic and the Western Massachusetts Railroads to Bridgeport and thence over the New York and New Haven Railroad to New York, but this route soon proved to be more circuitous and expensive than expected.

Cornelius Vanderbilt endured a stream of criticism and outrage from all parts of the state. The *Brooklyn Daily Eagle* wrote, "He is placing the metropolis in a state of strict blockade, and cutting off its supplies. We can imagine no act more criminal than this or deserving of exemplary punishment." The *New York Herald* also offered its condemnation:

> Our New York telegram announced yesterday that the Hudson River Railroad had broken the connection with the Central Railroad, and that travelers West and South would have to purchase their tickets separately upon each route. Freight upon that road will only be delivered at East Albany, or received at that point. When the rivalry of railroad companies results in the reduction of fares, the public gains, at least temporarily. But this is a contest carried on at the inconvenience of the public. It is to Mr. Vanderbilt, who controls the Hudson and Harlem Roads, but who failed to get control of the Central Railroad at the late election, that this condition of things is doubtless owing. The Buffalo Advertiser declares the movement is undoubtedly an attempt on the part of Mr. V. to coerce the New York Central into making some contract unfairly to the advantage of the Hudson; and, with his usual disregard of the rights of others, when they conflict with his own views or wishes, he has entirely disregarded all consideration for the convenience and comfort of the traveling public, in order to compass his project. Mr. Vanderbilt has been engaged in other fights of this sort, but never in one by which the public has been threatened or afflicted with so much discomfort, annoyance and loss as now impends.

State senator Henry Murphy introduced a bill that would require connecting lines to carry through passengers and freight and to refer all

disputes to arbitration (something that William offered to the Central a few days before the blockade was declared). However, Vanderbilt stood firm, knowing that the longer he could hold out, the more likely that the Central would suffer a financial crisis.

The state assembly's Railroad Committee demanded an investigation. Officers of both railroads were forced to testify about the events that caused the blockade. William gave a detailed history of the dispute between the two railroads, including the revocation of the $100,000 payment pact. He added that the Hudson River Railroad had eighty-two engines and enough freight cars to transport two thousand tons of freight per day. The New York Central was demanding that the Hudson road maintain that equipment to do its business for ninety days of the year and leave it standing for the remaining nine months while river navigation was open.

When it was Vanderbilt's turn to testify, an assemblyman asked him why he didn't sue the Central for breach of contract, since it was legally bound to pay it. "When you talk about legally, it is not according to my mode of doing things, to bring a suit against a man that I have the power to punish. The law goes too slow for me when I have a remedy." When the committee charged that Vanderbilt was holding the entire state hostage by failing to send his trains across the river, he surprised them by producing a long forgotten law still on the books that prohibited any river crossing by a railroad. When he was further pressed as to why his trains stopped a mile away from the riverbank, he replied that he didn't know. "I was playing a rubber of whist," he said blandly. "And ye know, gentlemen, I never allow anything to interfere with me when I'm playing cards. Ye got to keep your attention fixed on the game."

His testimony had the effect of changing public opinion from that of outright hostility toward the Vanderbilt family to hostility toward the directors of the New York Central. Henry Keep became increasingly desperate for a solution and appointed a three-man committee to negotiate with Vanderbilt. A new contract was signed in which the Central agreed to deliver as much freight to the Hudson River as the Hudson River delivered to the Central. In addition, the Central agreed to pay the Hudson River's back terminal charges.

Fargo and Keep not only lost the support of the Central's board in the wake of Vanderbilt's victory but also lost heavily in attempting to sell its stock short. Vanderbilt had acted before they were ready, foiling their plans and allowing Vanderbilt himself to profit by selling the stock short at just the right moment.

The massive freight operations of the New York Central created a powerful incentive for capitalists such as William Fargo and Cornelius Vanderbilt to gain control. Pictured is a typical large freight shed in Buffalo. *Library of Congress.*

Demoralized in his defeat, Keep began selling his shares of Central stock. The price fell as thousands of shares flooded the market, compounding the fall in price during the blockade. Vanderbilt, meanwhile, quietly told his friends to "buy and hold" the now cheapened shares as he himself began to reacquire an interest in the Central. After a few months of enduring the enmity of Central stockholders and members of the board, Keep resigned the presidency. He was succeeded by H. Henry Baxter, who wisely chose to take a more moderate approach in his dealings with Vanderbilt and the Hudson River Railroad.

During 1867, Vanderbilt began to exert more influence over the Central. The board voted to end its relationship with the People's Line and send all freight to the Hudson River Railroad. The *New York Times* reported that the Central and Hudson River Railroads had formed a close alliance for the first time since their formation.

Throughout the summer and autumn months, Vanderbilt continued to accumulate shares of Central stock while encouraging his friends and allies

to do the same. The share price declined from 130 before the blockade to 95 one month later, making it easier for a small group to gain voting control. One account claimed that Vanderbilt held $6 million of the Central's $23 million capital in his own name alone. By the second week of November, he calculated that he would hold enough stock and proxies to take control of the company. To show the public this fact, several letters were published from prominent stockholders to Vanderbilt asking him to accept the presidency of the New York Central in the next election and carry out "a thorough reformation in the management of its affairs." One such letter appears here:

*NEW YORK, Nov. 12, 1867.*
*C. Vanderbilt, Esq.:*

*Dear Sir: The undersigned stockholders of the New-York Central Railroad Company are satisfied that a change in the administration of the company and a thorough reformation in the management of its affairs would result in larger dividends to the stockholders and greatly promote the interests of the public. They therefore request that you will receive their proxies for the coming election, and will select such a Board of Directors as shall seem to you to be entitled to their confidence. They hope that such an organization will be effected as shall secure to the company the aid of your great and acknowledged abilities.*

*Yours respectfully,*

*Edward Cunard, John Astor, Jr., Bernard V. Hutton, John Steward, and others representing over thirteen millions of the stock.*

In a complete reversal from the year before, Vanderbilt came to the annual board meeting controlling $18.8 million out of the $20.0 million of stock that was voted. The entire board was immediately replaced, the new members of which then voted Vanderbilt president. His son-in-law, Daniel Torrance, was made vice-president until the position was filled by his William.

A year after taking control, Vanderbilt nearly doubled the stock capitalization of the company to $43 million. He went about it with utmost secrecy; only two members of his board of directors—Chester Chapin and Vanderbilt's son-in-law, Horace Clark—had any idea of his intentions. His son William later admitted that even he was kept in the dark and in fact sold large blocks of Central stock at a great loss just days before the operation

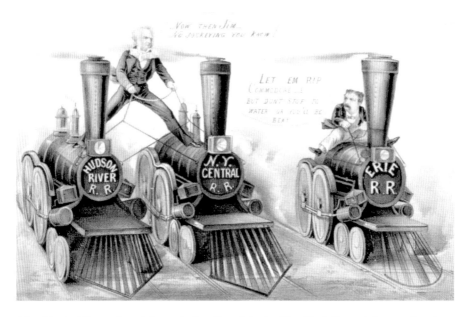

After Vanderbilt purchased the majority of stock in the New York Central, he put plans in motion to extend his railroad empire west to Chicago despite the efforts of Jim Fisk and others to stand in his way. *Library of Congress.*

went through. After ironing out the details in a clandestine midnight meeting, the three men announced an 80 percent dividend on New York Central stock. As the largest shareholder, Vanderbilt was suddenly the owner of many thousands of new shares. His speculative winnings must also have been significant. He reportedly purchased 130,000 shares of stock a few days before and watched with satisfaction as the stock price rose from $120 to $160 per share, giving him a net profit of $5 million.

In modern times, the practice of splitting stock or paying out stock dividends is common and elicits little controversy. In the mid-1800s, however, the public viewed Vanderbilt's actions with deep suspicion. A temporary injunction was issued by the Supreme Court that raised the question of the board's power to issue such certificates. There was another order for the examination of Vanderbilt, Augustus Schell and Horace Clark. After hearing their testimony, Judge Ingraham ruled that the board did have the power to issue the stock but did not have the power to issue dividends. In effect, he made the entire stock issue worthless. However, the matter was taken up with the legislature, which proved to be much more compliant. A special committee of the assembly submitted a short bill that authorized the

# The New York Central War

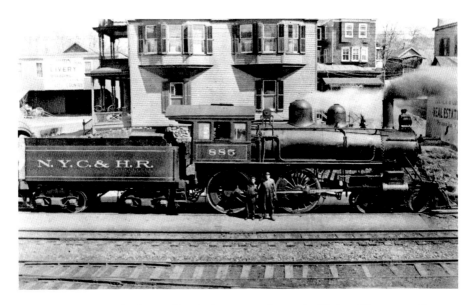

Competition among the three railroads that operated near the Hudson River naturally came to an end once Vanderbilt took control. Pictured is New York Central and Hudson River Railroad locomotive no. 885 on the Brewster Local of the Harlem Railroad. *Joseph A. Smith Collection (Carl F. Graves)*.

stock, which passed both the assembly and the senate before being signed by Governor Hoffman. In his memorandum, the governor noted that despite the "alleged haste and secrecy with which the scrip dividend was made," general railroad law authorized such increases in stock.

For a year, the New York Central and Hudson River Railroads were operated independently, if no longer competitively. The uniting of the two roads into one was the logical conclusion, and in November 1869, Vanderbilt asked the legislature to approve it. Despite the fact that the entire system was built for less than $20 million, he increased the stock capitalization to $86 million. The holder of each $100 share received two shares of stock in the new company. This was almost pure "water" at the time, since no improvements were announced until later. Vanderbilt pocketed $6 million in cash and $20 million in stock during this transaction in addition to the "watered" shares. The transaction gave him even greater control over New York's great trunk line and a personal fortune that enabled him to maintain that control for the rest of his life.

Critics of these stock-watering operations lamented that such tactics weakened the railroad in the long run. In order to maintain the dividends

that stockholders came to expect, the railroad had to pay out about $7 million per year, of which as much as $5 million represented dividends on "watered" issues. To raise this money, high freights were levied on local traffic, and expenses were trimmed using such measures as retaining rolling stock passed its useful life and delaying maintenance.

Between the profits he made in the stock transactions themselves and the dividends he received on the real and watered stock over eight years, it is estimated that Vanderbilt cleared $40 million. His method for accumulating so much wealth was cynically summarized by some news reports as, "(1) Buy your own railroad; (2) stop the stealing that went on under the other man; (3) improve the road in every practicable way within a reasonable expenditure; (4) consolidate it with any other road that can be run with it economically; (5) water its stock; (6) make it pay a large dividend."

Stockholders both big and small tolerated this stock watering for one very good reason: they profited from it. The New York Central became an efficient, smooth-running system that paid regular dividends during periods of prosperity and recession. Although not all of the stock sales were supported by property investments, Vanderbilt was not hesitant to upgrade the infrastructure enough to keep the road operating at peak performance. He issued $40 million in bonds to quadruple-track the route from Albany to Buffalo (two for passengers and two for freight), which became the wonder of the railroad world. A rail link between Spuyten Duyvil and Mott Haven near Manhattan allowed Hudson River trains to utilize a common East Side terminal. Iron rails were ripped up and replaced with steel, wooden bridges were taken down and the Grand Central Depot was erected in Manhattan. Superfluous ticket and freight agents were dismissed, and everywhere efficiency and economy were prized above all else.

As a result of these improvements and changes, the earnings and traffic of the New York Central and allied lines increased dramatically. The Central became the preferred passenger route from New York to Chicago, while unprecedented amounts of grain, cattle and lumber were shipped by rail for the first time rather than by canal. The stock price was stable in an era when many other stocks fluctuated wildly, leading the *New York Tribune* to declare that for all of his faults, "Vanderbilt has done more to restore confidence in railway management than any living man." All of this was done without the use of overt treasury plundering that plagued other companies. Frustrated Erie Railway stockholders from England reportedly begged Vanderbilt on three different occasions to assume its management.

# The New York Central War

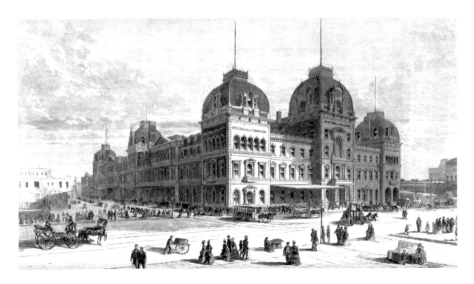

Vanderbilt celebrated his stunning victory in the New York Central war by erecting the Grand Central Depot in Manhattan, one of the largest passenger stations in the world.

Not content to control one of the country's four trunk lines, Vanderbilt expanded the war westward. Through the agency of his son-in-law, Horace Clark, and other allies, he began purchasing an interest in the Michigan Southern and the Lake Shore Railroads, which would give the Central a direct outlet to Chicago. He entered into a fierce contest with Legrand Lockwood, treasurer of the Lake Shore and a friend of Henry Keep's. In the Black Friday gold panic of 1869, Lockwood and company were forced to put up Lake Shore securities to keep themselves solvent, but the crisis was too great and they were ruined. Vanderbilt took advantage of their predicament and purchased a controlling interest. Once he installed Clark as president, Vanderbilt made history by personally controlling the first continuous rail route from New York City to Chicago. Although Vanderbilt wouldn't win every railroad war, he won the important ones in the Hudson and Mohawk Valleys, making him the most powerful "railroad king" in the country.

# The Susquehanna War

The vast majority of the population of New York was clustered along the Hudson and Mohawk Valleys for many years and was served by the Hudson River and New York Central Railroads. However, the fertile agricultural region of southern New York was bypassed by both the New York Central and the Erie Railroads, prompting a movement led by Albany merchants to build a railroad through the Susquehanna Valley from Albany to Binghamton. This untapped region consisted of 4,200 square miles containing fifteen thousand farms and 150,000 people.

Construction of the Albany and Susquehanna Railroad began in 1853 with great enthusiasm, but it wasn't until the winter of 1869 that the railroad was opened to traffic. The immense cost of building the road could not be raised by private subscription alone, so a bill was introduced in the assembly authorizing towns along the proposed route to subscribe to the stock of the company, but it was defeated in the senate. Two subsequent bills were also defeated. In 1863, a bill making an appropriation from the state of $500,000 was signed by Governor Seymour. This funded the line from Albany to Oneonta. A further loan of $250,000 was obtained to extend the tracks to Broome County. Finally, a loan of $1 million from the city of Albany was received to finish track construction.

When the railroad was completed, its route commenced at Albany, followed the Normans Kill and Hare Creek, crossed Schoharie Creek, ascended the Cobles Kill, descended the Schenevus Creek and Susquehanna River to Ninevah and followed Osborn Hollow to Binghamton, a distance

# The Susquehanna War

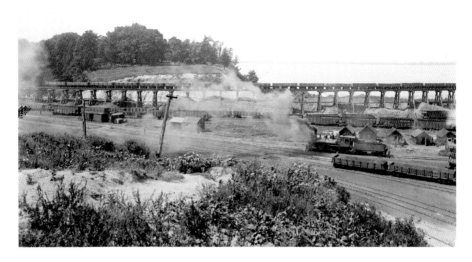

Jay Gould hoped to gain control of the Albany and Susquehanna Railroad to give the Erie Railway another outlet for its coal mining operations. *Joseph A. Smith Collection.*

of 143 miles. In addition to its valuable connections with the New York Central at Albany and the Erie Railway at Binghamton, it had access to the anthracite coal fields of Pennsylvania. The right-of-way was laid with broad gauge track, indicating that one of the purposes of the railroad was to interchange freight with the Erie Railway.

It is little wonder that two of the great railroad magnates of the time and directors of the Erie Railway, Jay Gould and Jim Fisk, coveted the new railroad as a potentially valuable link to both Albany and the Pennsylvania coal fields. From Albany, they could gain entrance to New England over the Boston and Albany Railroad and into the North Country via the Rutland Railroad. In the fight for the Susquehanna, their hand was strengthened by the division in the board of directors. President Joseph Ramsey created friction among the board by paying himself $16,000 for services that he claimed to have rendered as an attorney and refusing to let the Finance Committee examine the invoice. On another occasion, he made a contract with an express company in which it was later discovered he was invested. In the elections a year before operations commenced, a faction of stockholders opposed to his leadership appointed several men tasked with keeping his actions in check. Thus, Ramsey was in the minority of the board at a time when he would need all the support he could get in his battle with Gould and Fisk.

The Albany and Susquehanna had an authorized capital of forty thousand shares at $100 par value. Of these, a little over seventeen thousand shares were issued. Three thousand additional shares were disputed because they were forfeited for nonpayment of assessments and were reissued to investors at an amount equal to 25 percent of par. An election was approaching in September of that year, so each party had until that time to secure as much of that stock as possible to use in voting for a new board of directors and thus control the railroad. What followed was a war in the economic as well as the physical sense, complete with "armies" contesting a field of battle.

The opposition party within the board of directors, backed by Gould and Fisk, began purchasing as many shares of stock as were available on the market. The group included prominent men from the towns of Cobleskill, Unadilla, Maryland and Milford who were in a position to pledge the stock owned by those towns. A law required that towns owning the stock could not sell it for less than the $100 par value, and then only for cash. Although the stock price was bid upward due to the sudden buying spree from the previous low of $25, the share price reached only $65 per share, meaning that the Erie interests would have to pay an additional $35 per share above the market price if they wanted to gain control of the railroad. Fisk reportedly exclaimed, "Damn the expense! We've got to have that stock, haven't we? All right then, we'll buy it, by Jiminy Crickets!" He sent men up the line with bags full of cash to buy the towns' stock for $100 per share, provided they could immediately take possession of it.

Gould furnished the capital to purchase these stocks, which were transferred on the Albany and Susquehanna books. Ramsey caught wind of the daring move and sent his own messengers to these towns, warning them that if the infamous Wall Street team of Fisk and Gould got a hold of the railroad, they would raise freight prices so high that nobody could afford to pay them. The sight of a bag full of cash was enough to persuade at least a few towns to sell, though, since Fisk was able to quickly accumulate seven hundred additional shares of stock. However, when it came time to transfer the stock that was purchased from Oneonta, the town treasurer refused to deliver it. An injunction was obtained against the stock transfer, and before the injunction could be canceled, the company books were secretly taken from the Albany office and hidden inside a tomb at a nearby graveyard and afterward carried from place to place for an entire month. The stock owned by Davenport was also purchased and paid for, but likewise the transfer was refused. Nevertheless, Gould voted on both the Oneonta and the Davenport stock, as well as stock purchased from the other towns.

# The Susquehanna War

A firm connection in Binghamton with the Albany and Susquehanna would have given the Erie Railway a gateway to the New York Central's backyard in the Capital Region and on into New England. *Library of Congress.*

Meanwhile, Ramsey and his supporters did not sit idle. On August 5, he assembled those directors who were allied to him at his home and passed out 9,500 shares of previously unsubscribed stock. Only 10 percent of the par value was paid for the stock, and this would be provided for by Ramsey. It was also agreed that if any of the subscribers did not wish to keep their stock, Ramsey would take it back after the election.

To cover the $95,000 required by this stock subscription, Ramsey drew a draft of $100,000 from David Groesbeck and cashed it. To secure Groesbeck, Ramsey gave him collateral worth $150,000 consisting of equipment bonds of the company that he took from the treasury for that purpose. With the 10 percent thus paid in this dubious transaction, the shares of stock were entered on the books and thus gave Ramsey the power to vote with them in the upcoming election.

Contemporary critics called these actions illegal or suggested that they were at the very least not carried out in good faith. Many in Albany, however, believed these were justifiable under the circumstances, given the reputations of Gould and Fisk in the railroad world. Though they had not done anything illegal in regard to purchasing stock in the Albany and Susquehanna, the pair previously set "infamous precedents" in other affairs, particularly the wholesale ransacking of the Erie Railway's finances.

A flurry of legal injunctions and court motions thrown back and forth between the opposing sides was made possible by the function of the judicial system of the day. Rather than answering a complaint issued by a judge, offending parties very often found a "pliable" judge in another town who issued a counter-complaint against his adversary. An injunction was one of the favorite weapons of the railroad wars. They could be obtained from any who asked and were often granted without the knowledge of the other party and handed directly to the complainant or his attorney at the most strategic moment. There were thirty-three judges in New York State elected in eight districts, all having equal power and whose jurisdiction had no boundaries except the borders of the state. Each one had the right to rule on a topic regardless of prior rulings. This would sometimes result in one judge ordering a person to take one action and another judge in a different part of the state issuing an injunction against that action. The Susquehanna parties would soon find themselves bound by one of Calvin's creeds: "You shall and you shan't; you will and you won't; you're condemned if you do, and you're cursed if you don't."

Lawsuits began to pepper the legal system from both parties. Ramsey commenced the first one on behalf of Oneonta to restrain the transfer of seven hundred shares of town stock. An injunction was granted by Judge J.M. Parker of the Supreme Court, but days later, the injunction was struck down when proof was given that the stock was legally purchased in good faith and at full par value.

The next lawsuit was filed by the Gould party against Ramsey to compel the transfer of the Oneonta stock to the company books. A second lawsuit contended that Ramsey issued three thousand shares of company stock to various parties who paid less than 25 percent of the par value; that he ordered the treasurer not to transfer certain shares of stock to persons who bought it; that he caused collusive suits to be brought against legitimate owners of the majority of stock to sway the results of the upcoming elections; and that forty-four shares of stock were issued to a man named Goodyear without payment of par value to the company. The lawsuit asked that Ramsey be removed from the presidency and that all defendants be restrained from issuing any more stock. Judge George Barnard made an order the same day barring Ramsey from issuing stock and to refrain from exercising the offices of president and director until there was another order from the court.

Ramsey defied these orders and submitted a countersuit that alleged that the defendants "had entered into a wicked and corrupt conspiracy and combination to transfer the corporate property and franchises" of the Albany

# The Susquehanna War

James Fisk (1835–1872) played a major role in the Susquehanna War, personally lobbying legislators and towns on behalf of the Erie Railway and even acting as receiver for the Albany and Susquehanna Railroad.

and Susquehanna to the Erie Railway. A sympathetic Albany County judge granted Ramsey an injunction that restrained four of the directors, Vice-President Herrick and Treasurer Phelps from acting in their respective roles.

The board of the Albany and Susquehanna was now in a shambles. Ramsey and five directors were barred by various judgments from acting as directors, leaving only eight with the legal competency to act. There was no provision to appoint a new president when both the president and vice-president were incapacitated, so the day-to-day business of the railroad could not be carried on in the manner prescribed in its charter or bylaws. Payments had to be signed by a majority of the executive committee, all of whom were suspended.

The only solution was to put the railroad into the hands of a receiver who had the power to release payment obligations. A suit was instituted in the Supreme Court by Azro Chase, a stockholder and director, to force Ramsey to step down and appoint a receiver until a legal meeting of the board could act on the appointment of a new president.

Amid much criticism from Albany that he was biased as "the favorite judge of these litigants," Judge Barnard sided with the plaintiff and assigned Jim Fisk and Charles Courter of the Erie Railway as receivers. The two promptly traveled to Albany to demand possession of the office, books and other property of the railroad company. Meanwhile, Judge Peckham of the Albany Supreme Court signed a conflicting order making Robert Pruyn

receiver of the road based on a complaint made by General Superintendent John van Valkenburgh. With two different receivers appointed by judges from different counties, the parties were at an impasse.

Fisk, Coulter and a few dozen bodyguards arrived in Albany with Judge Barnard's injunctions in hand and went at once to the railroad offices located near the Hudson riverbank. There they found Van Valkenburgh in command, and he announced that Robert Pruyn was the lawful receiver. A heated argument followed, with Fisk insisting that he was going to take charge "if it took millions of money and an unlimited number of men." To illustrate his point, he summoned the Erie men, whereupon Van Valkenburgh presented a similar group of Susquehanna employees. A brief fistfight ensued that ended with Fisk and his men being ejected into the street. A policeman appeared through the crowd, and a chorus of bystanders accused Fisk of forcing his way into the office. Fisk was taken to police court but was soon released. He returned to the Susquehanna office much subdued and approached Ramsey, who appeared weary from the ongoing court battles. Fisk suggested that they settle the whole affair by playing a game of "Seven Up," the winner taking the Albany and Susquehanna. Ramsey smiled but said "No." He had other people to think about besides his own interests.

The suits flying back and forth continued as each side sought to gain the upper hand. On August 7, Ramsey instituted another complaint against Gould, Fisk and others as the "principal instigators and plotters in a corrupt conspiracy to gain control and possession of the plaintiff corporation in order to subserve their speculations in its stock" and to transfer its franchises and other property to the control of the Erie Railway, which would bring "great detriment and certain ruin" to the Albany and Susquehanna. Ramsey also alleged that if Gould and Fisk were unable to vote with a majority of stock at the September meeting, they were threatening to prevent an election "by the illegal and fraudulent use of the process of the court." The suit asked that all directors involved in these "fraudulent" proceedings be removed from office and an injunction be put in place that barred Gould and Fisk from acting or claiming to be receivers. Judge Peckham not only signed an order that restrained the Erie group from prosecuting any of its suits but also forbade any party from bringing suit against the Ramsey interests until a formal decision could be made in court. Writing for the *New York Tribune* a month after these events unfolded, Horace Greeley noted, "Injunctions and counter-injunctions now became so many and so puzzling that the shrewdest counsel could hardly keep count of them. Then came scenes so extraordinary that no honest citizen can recall them without blushing."

# The Susquehanna War

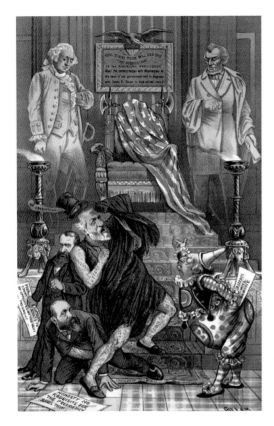

The judicial system was in disarray in the decades after the Civil War and was lambasted by the press for its inconsistencies and corruption. Jay Gould (left) was often vilified for his flagrant bribery of New York State judges. He was also accused of bribing Congressman James Blain (center) for favorable legislation.

The legal proceedings being played out in the courts suddenly spread to the "field of operations" along the line of the Albany and Susquehanna. As one account put it, "At last the two parties, mutually scared by the cross-fire of conflicting injunctions which the courts were launching at all alike, sought relief in the more peaceful arbitration of pike and gun." Fisk telegraphed Judge Barnard's order to Sheriff Browne of Broome County, who set off with the telegram in hand to take possession of the Binghamton station. He and twenty deputies then seized two locomotives (a third escaped and headed back toward Albany) and a passenger train and held them at the station for Fisk's use. The regular crew was removed and an Erie Railway crew installed.

The newly acquired passenger train powered by an Erie locomotive made its way east toward Albany, pausing at each station to depose the agents and replace them with Erie men. Upon hearing this, Van Valkenburgh in Albany ordered all trains to stop at the nearest station and remain there to

guard against the rapidly approaching Erie train. The sheriff's train made it as far as Afton when a telegram from Van Valkenburgh warned him that if he continued, it would be at his own peril. An extra train was sent west from Albany to meet the Erie train with 150 men under the supervision of Master Mechanic R.C. Blackall. Meanwhile, Fisk reinforced the Erie train with extra men from the Binghamton shops and ordered it to continue east despite the warnings.

Arriving in Bainbridge, about thirty-five miles from Binghamton, Blackall ordered the train to take a sidetrack and lie in wait for the Erie train to arrive. He turned out all the lights and placed a pair of frogs, normally used for getting derailed trains back on the tracks, reversed on the rails. The Erie train ran into the frogs and left the tracks, fortunately remaining upright. The sheriff and his force of forty men were quickly overwhelmed by Blackall's forces and surrendered without a fight.

By this time, newspaper accounts of the feud arrested the attention of the general public, which became fixated on the events taking place outside Binghamton. Incredulous accounts of the Susquehanna War were related around the country on a daily basis, such as these from the *Hudson Evening Register*:

> *Binghamton, August 9.*—*This afternoon at 2 o'clock, Sheriff Brown seized the office and what rolling stock of the Albany and Susquehanna Railroad he could get possession of, on authority of a writ of Judge Barnard of New York. Three engines were seized by the Sheriff; one escaped, and is probably now making good time for Albany. An engine from the Erie Railway was placed on a 2:30 passenger train, but was not allowed to leave the track at the depot. A train started however at 3 o'clock, drawn by an Erie engine and in charge of an Erie conductor. Superintendent Pratt, of the Erie Railway, has been appointed Superintendent of the Albany and Susquehanna Railroad by James Fisk, Jr., as receiver.*
>
> *Binghamton, August 10.*—*The absorbing subject of interest in this city is the Erie and Susquehanna railroad war. It is in the mind of everybody; little else is talked or thought of. The general anxiety has been intensified by the fact that all operations here are conducted with great privacy. One hundred and fifty men, composing the Erie fighting corps, were armed with revolvers, and is reported that the Albany party is likewise armed. The city is full of rumors. The only trustworthy intelligence from the scene of operations is that at eight o'clock the Erie men drove the other party into a tunnel. Some shots were fired, and one of the Erie party had his hand shattered by a shot. The militia from this city had just arrived at the tunnel near Harpersville. A*

# The Susquehanna War

*locomotive was taken through the tunnel and came in collision with another locomotive at the other end. The Ramsey men then attacked the Erie men and drove them back. Each party now holds possession of one end of the tunnel. Everything is now quiet and both parties are waiting for daylight.*

Blackall waited until morning before heading farther west toward Binghamton, restoring each station to Albany and Susquehanna control as he went. At the tunnel outside Binghamton, the two forces again met. This time Blackall's group was outnumbered. Even though reinforcements arrived to boost his force to 450, Fisk quickly gathered 850 men from the Erie shops and sent them on a special train to meet Blackall. The two trains collided at low speed on a curve outside the tunnel, causing hundreds of men to leave the train and lunge at one another with clubs and fists. Shots rang out, and the Erie men, despite their superior numbers, retreated through the tunnel or into the surrounding countryside toward Binghamton.

Luckily, no one was seriously hurt in the melee, but further conflict seemed inevitable. The Erie men regrouped on the far side of the tunnel and prepared to hold the line against the opposing train that slowly bore down on them. Having fought it out once that day, however, the combatants didn't seem to be in a mood to engage one another again, and the conflict was limited to shouts and threats. Meanwhile, to restore order Broome County officials called out the state militia, which arrived before more fighting broke out. The Albany force headed back toward Harpursville, blocking the track at the tunnel with a derailed freight car.

The situation degenerated from comical to dangerous as Susquehanna rail operations ground to a halt and towns along the line braced for further violence. Many were used to the antics of Empire State railroad barons. However, even the jaded outlook of citizens accustomed to watching railroads and other industries plundered by tycoons were aghast at the conflict.

With the courts in deadlock and "armies" of railroad workers engaged in open warfare, Governor John Hoffman was asked to come back to Albany from his summer vacation at West Point and intervene in the interest of restoring the peace. On August 11, representatives from both sides met in the executive chamber and requested that the governor appoint a neutral party to act as superintendent until the September election. He was also asked to employ such operational and financial agents as he deemed necessary. During the meeting, Fisk got into a heated argument with Van Valkenburgh and was arrested. After posting bail, he returned to Delevan House in Albany, where he established his headquarters until a final decision could be made.

# Railroad Wars of New York State

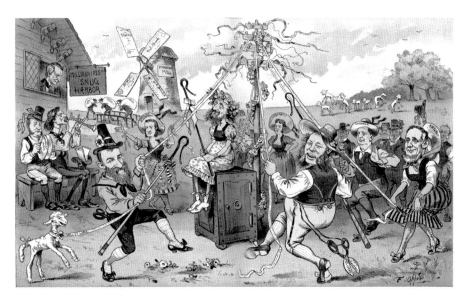

In an age with little governmental regulation, millionaire capitalists were often portrayed negatively in the press for their greed and deceit. Front and center in this editorial cartoon are Jay Gould (left) and William Vanderbilt (right). All are dancing around a maypole at "Millionaires Snug Harbor." *Library of Congress.*

The governor was ready to exercise his civil power in taking temporary possession of the railroad, but in light of the ongoing bitterness between the factions and the multitude of injunctions, counter-injunctions and violence that had taken place, he thought it was more appropriate to take a "quasi-military" possession. Colonel Robert Banks was appointed as executive financial agent, and Adjutant General James McQuade was made superintendent. Still fuming from his arrest, Fisk managed to get an order for the arrests of Pruyn, Ramsey and Van Valkenburgh, all of whom were taken to the executive chamber to see Governor Hoffman. Judge Clute issued a writ of habeas corpus and ordered their release from arrest. The action by Fisk aroused further sympathy for Ramsey and even greater prejudices against the Erie group.

The efforts of the governor's appointees were somewhat hampered by the fact that the books of the company were still kept in hiding and only returned to the office on September 6. Strenuous efforts were made by the Erie interests to locate them, since there was no way of knowing what stock was issued and no means of protecting themselves against votes on fraudulent stock. Detectives traced the books to the house of Director Henry Smith, but by the time they got there, the books were gone. A clue led them to Pittsfield, Massachusetts, where it was found that Superintendent Van

Valkenburgh had spirited the books a few days previously, but again the agents were foiled.

The annual stockholders meeting held on September 7 promised to offer plenty of conflict and intrigue, as both sides went into the meeting claiming to have a majority of voting stock. Ramsey claimed to possess almost 17,000 of the total 29,738 shares issued, compared to 10,000 held by the Erie faction. However, Fisk alleged that 12,500 shares were issued illegally—the 3,000 original shares that were sold for less than par value and the 9,500 shares that were issued by Ramsey at the secret meeting. The entire fate of the railroad rested on whether the 9,500 shares would be deemed legal or fraudulent.

The scene at the meeting was exceedingly tense, many believing that violence was about to break out at any moment. Fisk brought a group of railroad men with him to make sure the proceedings were "fair and balanced," while Ramsey and his supporters brought their own group of "toughs," some armed with clubs. Outside the building, another large crowd from the neighborhood gathered to see what would happen.

The rooms where the meeting took place were on the second floor of the office building, consisting of the superintendent's office, the library, the director's office, the president's office and the treasurer's office. All of these rooms were connected together and had access to a center hall. The meeting began in the director's office, which quickly filled with officers, directors and the several dozen railroad men brought in by the Fisk and Ramsey parties. What followed was perhaps one of the most bizarre board of directors meetings ever held.

Colonel North, as acting chairman, called the meeting to order and nominated one of the Erie faction as chairman, who was elected by a voice vote. Resolutions were put forth to declare the three offices of inspectors to be vacant, and other men from the Erie group were elected by voice vote over the objections of the Ramsey faction. The three inspectors passed into the treasurer's office to prepare a poll for voting on the election of directors. One of the Ramsey attorneys approached the desk and read aloud an injunction issued by the Supreme Court that barred any inspectors from being elected. In the meantime, Ramsey formed another stockholders' meeting in the center hall. Three different inspectors were appointed in this meeting who also entered the treasurer's office and announced that they were opening a poll of their own for choice of directors.

The proceedings continued in the face of yet two more injunctions that were granted before the meeting. Jay Gould persuaded Judge Barnard to prohibit anyone from voting on the 9,500 shares of stock issued by Ramsey on August 5, while a counter-injunction issued by Judge Clute of

Albany County specified that no votes could be accepted from the Erie faction unless the holders of the same 9,500 shares had an opportunity to vote on them. Other injunctions instituted by Ramsey forbade voting on the stock that was purchased from the towns of Oneonta, Cobleskill, Unadilla and Milford.

The missing books mysteriously appeared at the company offices the night before, and Fisk alleged that Ramsey brought them there by using a basket tied to a rope at the rear of the building to avoid detection. Ramsey was arrested on a warrant issued by Judge Barnard on the basis that he unlawfully "abstracted and concealed the books and withheld them from the inspection of the stockholders." Bail was set at $25,000, which was promptly posted and the proceedings continued. The shenanigans ended with the Ramsey faction electing Ramsey as president and the Erie faction electing Colonel Church as president.

Governor Hoffman's agents continued to control the railroad, while twenty-two separate legal actions wound their way through the courts. The attorney general was called on to settle the numerous disputed questions, and a trial was conducted in Rochester under Justice E. Darwin Smith. Fisk and Gould offered to lease the railroad for ninety-nine years, the rental amounting to 7 percent on the stock and bonds and a one-time 30 percent dividend. Ramsey refused, believing that he had the upper hand in the trial.

In January, the court ruled in favor of the Ramsey board on every count. Judge Smith determined that the suit under which the Barnard order of arrest was issued against Ramsey was instituted without legal authority, that the order to hold bail was "most extraordinary and exorbitant" and the injunction forbidding Ramsey to act as president of the company was "entirely void." Even the 9,500 shares of new stock issued by Ramsey, on which no one voted at the election, were declared to be valid and binding. Further, Smith scolded Fisk for allowing "rough and dangerous persons" into the board meeting and furnishing them with proxies so they could participate in the meeting, which was a "gross perversion and abuse of the right to vote by proxy, and a clear infringement of the rights of stockholders."

Immediately after the court decision was announced, the Erie counsel appealed and successfully obtained a stay on all proceedings under the judgment. Judge Peckham quietly declared that the stay had no effect and granted an order putting the Ramsey board in possession of the railroad offices. The Erie Ring was not yet satisfied, and another motion was made to vacate the judgment based on Judge Smith's "unfairness, irregularity, bias, and conduct unbecoming a magistrate." The motion was pronounced

# The Susquehanna War

Jay Gould's antics during the Great Erie War factored in his defeat during the Susquehanna War, as citizens in Albany and elsewhere rallied behind Albany and Susquehanna president Joseph Ramsey, the lesser of two evils. *Library of Congress.*

"simply monstrous" and was stricken from the record as "irrelevant and impertinent." There was nothing left to do at that point but begin a long and expensive appeals process that could have lasted years. Gould and Fisk sold their shares of Albany and Susquehanna stock in disgust, and in February 1870, the railroad was leased to the Delaware and Hudson Canal Company in perpetuity. As one reporter put it, "This arrangement transferred the struggle from the comparatively weak shoulders of the railroad itself to those of one of the most powerful and wealthy corporations in the country—with it, the Erie managers could not afford to quarrel, so they were fain to profess themselves satisfied and to desist from the contest." Thus, the Susquehanna War came to an end in a rare and bitter defeat for Jay Gould and Jim Fisk.

# The Great Erie War

The Erie wars that were fought by and against directors of the Erie Railway spanned nearly half a century and infused the company with perhaps the most scandalous reputation in the industry. Rate wars with other railroads and fights among the directors began almost upon commencement of operations, but the so-called Great Erie War fought between Cornelius Vanderbilt and the "Erie Ring" represents some of the most outrageous events in all of railroading. The wars of the Erie were so extensive that they spilled over into other historical events, such as the Susquehanna War and the Gold Corner of 1869.

The ill-fated railroad was one of the first in the state to be chartered, organized with great fanfare and promise in 1832 as the New York and Erie Railroad. It was deemed such an important enterprise that the State of New York put up $3 million and private investors put up another million. The first section, from Piermont to Goshen, was opened in 1841, but financial mismanagement forced the young company into bankruptcy. Later, the state forgave the $3 million mortgage but stipulated that the company had to finish the line to Lake Erie within six years. The track was finally completed to Dunkirk in the spring of 1851 and formally opened for business. In an effort to keep freight traffic from leaving its tracks, the railroad was built using broad gauge (six feet between the rails) when most railroads were built using standard gauge (four feet, eight and a half inches).

As a connection between the outskirts of New York City and the western part of the country, the Erie Railway should have been among

# The Great Erie War

One of the Erie Railway's greatest weaknesses was its lack of direct connection into Manhattan—it had to break bulk and float freight across the Hudson River. This view shows the Chambers Street ferry terminal. *Library of Congress.*

the most profitable railroads. However, a series of corrupt administrations resulted in fraud and mismanagement on a wide scale, condemning the railroad to an existence of poverty and embarrassment. For example, Eleazer Lord, an influential director and president of the railroad for three terms, concluded during construction that piles would make better roadbed than grading. He therefore ordered piles driven for over one hundred miles at a cost of $1 million, but track was never laid on them. Competition from the New York Central, several bad crop years and an engineers' strike that cost the company $500,000 drove it into bankruptcy again in 1857.

Over the next eighteen months, management dedicated its efforts almost solely to borrowing money to meet operating expenses. Soon the interest on the debt became too great, and the railroad went into the hands of a receiver. The receiver made some needed improvements to the track and strengthened the railroad's link to New York City. The company was reorganized under the name Erie Railway and shed some of its debt by converting $8.5 million worth of bonds into preferred stock.

# Railroad Wars of New York State

Wall Street investor and steamboat owner Daniel Drew first became interested in the Erie beginning in 1850. This was at a time when Drew's Hudson River steamboat line was shipping most of the freight and passengers of the New York Central from New York City to Albany during navigation season (Cornelius Vanderbilt was not yet in control of the Hudson River Railroad). Drew was familiar with the territory that the Erie Railway served from his days as a drover, when he herded cattle across the southern counties of the state to Ohio and back. Seeking to gain eventual control of the railroad, he concocted a scheme that would force his admission as a director and open the door to further possibilities.

Drew already had influence over the New York Central on the eastern end of its line with his People's Line steamboats. He then quietly gained control of a line of steamboats that served the Erie Railway operating on Lake Erie and a tiny connecting railroad at the western end of the state called the Buffalo and State Line. When control of both ends of the state was in his hands, he announced plans to give the New York Central a lower through rate on the Hudson River and on the Buffalo and State Line Railroad. Faced with the prospect of unfavorable competition with the New York Central, the directors of the Erie gave Drew a seat on the board at the next meeting.

Now that he was inside the company, Drew worked on gaining control over it. He reasoned that if he could induce the railroad to borrow money from him, he could become an officer in charge of policy and issuing stocks. His plans were stymied because the railroad was relatively prosperous and paying regular dividends. However, Drew patiently awaited his opportunity and was eventually aided by two events: the Panic of 1857, during which the economy was briefly thrown into turmoil, and the effort by the Erie Railway to build a new route from Piermont, its current termination point twenty-four miles up the Hudson River, to Jersey City via a costly tunnel through Bergen Hill.

In an effort to complicate the project and further enrich his own wealth, Drew started rumors around Wall Street that sent the price of the stock alternately higher and lower. For example, when the Bergen Tunnel was being bored, he hinted that the tunnel was much more expensive than contractor estimates and might have to be abandoned. The stock dropped from sixty-three to thirty-three, and he was able to profit by selling the stock short.

Drew's actions also had the effect of limiting the railroad's ability to raise capital at a time when it was needed the most. The payroll was at an all-time high, freight yards were being constructed in Jersey City, the right-of-way for

# The Great Erie War

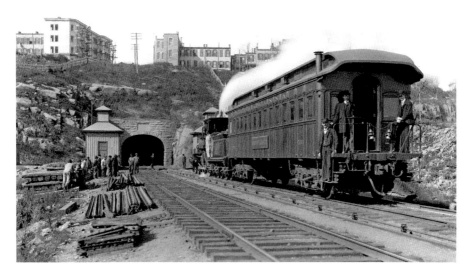

The heavy expense of boring through Bergen Hill, coupled with the Panic of 1857, drove the New York and Erie Railroad into bankruptcy. This allowed Daniel Drew to solidify his influence over the railroad through loans and stock manipulation. *Library of Congress.*

new lines had to be purchased, a dock was needed to unload freight on the river and a new freight station was being built. All of a sudden, the Erie was short of funds.

At a board of directors meeting, Drew generously offered to loan the railroad whatever it needed to continue rail construction to New York City. The board accepted, and the trap was sprung. He took as security a chattel mortgage on the rolling stock, and when the company was unable to pay back the loan, the directors were forced to appoint him as treasurer. Drew was completely ignorant of proper railroad management and had little desire to learn. During the next decade, he used the Erie as a means to manipulate the price of the stock and, in the process, cause a large number of investors to become speculators and lose millions of dollars, which often flowed into Drew's pockets.

One of his many schemes for manipulating stock prices was proudly related in his memoirs. At a time when Erie stock was high and climbing

higher, he would instruct his brokers to sell the stock short. After his short contracts were placed, he would send out a statement that he, as the owner of mortgages on the railroad, was about to foreclose. This would trigger a minor panic, and Erie shares would slump, allowing him to settle his contracts and reap the difference between the original price and the artificially lowered price. He would then execute his plan in reverse—buying the cheapened stock just before announcing that his difficulties with the railroad were happily resolved and that there would be no foreclosure after all. In fact, he was preparing to declare a huge dividend! The stock price shot upward, allowing him to unload his shares at the higher price and reap even more profits. He did this on multiple occasions that involved thousands of shares of stock. As Drew himself put it, "This is the advantage of operating from the inside; you win both coming and going."

Perhaps the most egregious example of Drew's stock manipulations, and the one that caught Cornelius Vanderbilt's attention, occurred just after the Civil War ended. In return for giving the Erie a $3 million loan, he took as security the equivalent in bonds that were convertible into stock, amounting to thirty-thousand shares, along with twenty-eight thousand shares of unissued stock that were on hand. With these in his pocket, he went to the stock exchange and sold the Erie short. The stock price was hovering at ninety-five and poised to go higher, so there were many investors who confidently purchased his contracts. As the weeks went by and the stock price remained steady, it looked as though Drew would lose all of the money he put up to secure the contracts. At just the right moment, he dumped twenty-eight thousand shares of stock on the market that no one knew even existed. The appearance of this huge block of stock caused the share price to plummet from ninety-five to forty-seven in one day. Therefore, Drew was able to pay $47 per share for stock that the others paid $95 for, according to the contract. He was able to pull of the bold maneuver despite the fact that those shares were not technically his to sell, since they were merely given to him to hold as security against loans that were not yet due. But as Drew would later put it, "In a business deal, you can't stop for every little technicality."

Vanderbilt, who had just locked up control of the Hudson River Railroad, looked on these speculations with impatience and disgust. He believed that if he could run the Erie in the same fiscally prudent manner as he did with the Harlem and the Hudson River Railroads, it would become a profitable company that could add even more value to his own railroad empire. Vanderbilt secretly began buying stock until he had enough to take control

of the board of directors. In concert with this action, he sought the assistance of a group of Boston investors who were substantial stakeholders in the Erie and who were also fed up with Drew's stock manipulations. Acting together, Vanderbilt and the Boston investors owned enough shares to dominate the next board of directors meeting and vote out the current management.

Facing ejection as treasurer, Drew traveled tvo New York to appeal personally to Vanderbilt for leniency. If it been anyone else, Vanderbilt would have likely thrown the man out on the street. But he and Drew had a long history together in the steamboat business, sometimes cooperating and at other times competing with each other. Vanderbilt had a soft spot for "Uncle Daniel," as he was known, whose career in many ways paralleled his own. Drew promised to work for the interests of the railroad and act as Vanderbilt's ally from within the company against the "set of bad men" who were attempting to take control.

In what would become the greatest mistake he ever made, Vanderbilt relented and caused Drew to be reinstated to the Erie Board one day after the elections kicked him out. He then further exacerbated his error in judgment by allowing Drew to install two other Wall Street capitalists, Jay Gould and Jim Fisk, onto the board.

Fisk was an associate of Drew's, having provided stock brokering services for him that turned out to be profitable for both parties. Gould recently sold his Pennsylvania tannery and came to Manhattan to seek his fortune in the stock market. Observing the millions that Drew was making in the Erie's stock fluctuations, he purchased some stock of his own and proposed to ally himself with Drew and Fisk against Vanderbilt.

In their capacity on the executive committee, the three men had the power to issue stocks and bonds, vote on improvements and generally exercise full authority. Vanderbilt continued purchasing shares of Erie stock, believing that it was in his best interest to have as much voting power as possible. Unknown to him, Gould, Fisk and Drew had secretly hatched a plan to dupe Vanderbilt out of millions of dollars and remove his influence from the Erie forever. The first part of the plan involved a proposal to replace all of the old iron rail with steel rail along the Erie lines, as well as laying a third rail so that freight cars of standard-gauge railroads could roll on the Erie's broad-gauge track.

To fund these expensive projects, the company would of course need to raise more capital. This was done by invoking the devious practice of issuing new bonds, supposedly to finance needed equipment and infrastructure upgrades. In reality, these bonds were issued as "convertible," so that they

could be converted into stock at the whim of the executive committee. The advantage of these convertible bonds was twofold: a provision in the Erie charter forbade the issuance of new stock except at par value, and the issuance of bonds that were later converted into stock would not raise red flags on Wall Street until they were actually recorded on the transfer books and put on the market.

The bonds were ostensibly to be used to fund the proposed improvements in the Erie's trackage, but as Drew would later say, "All's fair in love and war, and in this particular case I felt that I was more in need of this nine or ten million than the Erie Road was." Instead of replacing the old iron rails, he simply ordered that the iron rails be turned so that the unworn outer edge was facing the inside. Of course, this wasn't nearly as safe as laying new steel rails, but Drew decided that since he put in so much valuable time as treasurer of the Erie, he had a "right to sluice off some of her revenues" into his own pocket. This act left the tracks in such a dilapidated condition that the railroad was becoming known to the public as "two streaks of rust."

Openly declaring that he would soon own the Erie Railway, Vanderbilt prepared to gain a controlling interest through massive stock purchases. At a board of directors meeting held in January 1868, a favorable report of the road's condition was delivered by the superintendent. Upon the adjournment of the meeting, the executive committee met and voted to issue $10 million worth of convertible bonds. The trio famously went to a printing house and ran off 100,000 stock certificates to be used in the coming battle—50,000 shares for Drew to use immediately and 50,000 that were kept aside to be used later.

Drew converted $5 million worth of bonds into stock and ordered his broker to purchase it, guaranteeing him against personal loss. These were then distributed to various brokers in preparation for the great battle with Vanderbilt and were ready to be thrown on the market at the most opportune time. Vanderbilt told his brokers to buy any shares that were offered at any price. When it seemed as though there were no other shares left, new shares would suddenly appear. Vanderbilt suspected that something sinister was afoot, but he plunged ahead with his plan and ordered his brokers to continue buying. It was only when word came that Drew and Gould were selling Erie stock short that Vanderbilt realized it was they who were working against him.

Vanderbilt understandably flew into a rage over Drew's treachery and the possibility that he was buying thousands of shares of invalid stock. He called on Judge George Barnard of the New York State Supreme Court

# The Great Erie War

The Erie Railway should have been a first-class trunk line generating millions in profits, but it was doomed to mediocrity and neglect for several decades thanks to the plundering of its treasury by Daniel Drew and Jay Gould. Pictured is a yard at Salamanca, which grew dramatically when the Erie Railway joined with the Atlantic and Great Western to form a continuous link to Chicago in 1863. *Library of Congress.*

(a notoriously corrupt judge who was eventually impeached from office) to issue a writ enjoining the directors from issuing more stock and ordering them to return one-fourth of the stock already issued back to the Erie's treasury. Barnard also prohibited the conversion of bonds into stock on the grounds that it was fraudulent.

Drew and Gould countered the Barnard ruling by finding a judge of their own from Binghamton who issued an injunction ordering them to issue even more stock. This contradiction of rulings would not be possible today, but in the confusion of the Civil War Reconstruction period, the legal system was in disarray, and some people took full advantage of it. Vanderbilt felt safer once the Barnard ruling was made public and instructed his brokers to continue buying stock. However, Drew ignored the ruling and continued feeding additional shares onto the market.

Jay Gould (1836–1892) is acknowledged to be one of the greatest stock market speculators of all time, amassing $72 million through sheer audacity, often in the face of overwhelming opposition. *Library of Congress.*

When Drew's short contracts were about to come due, he and Gould delivered the final blow. A contract of the sale of the remaining $5 million bond issue was drawn up that gave Drew the power to dispose them as he saw fit. He slyly made a demand that the bonds be converted into stocks as per the contract, which was of course refused due to the Barnard injunction. The intention of Drew's actions, however, was to obtain a contradictory injunction by a favorable judge that compelled him to convert the stock. Within this confusion of conflicting writs and injunctions, the Erie Ring was able to operate with near impunity.

The newly converted fifty thousand shares of stock were bundled and handed off to a messenger to take to the transfer office, where it would be recorded and come to public attention. However, Gould arranged for the bundle to be "stolen" from the messenger and secreted to a broker's office, which, on his orders, dumped the shares onto the market just as Drew's short contracts came due. Vanderbilt's brokers reacted with surprise at the sudden appearance of so many shares, but since there was a standing order to buy all that were available, they continued purchasing them throughout the day. It wasn't until the market closed and all accounts were settled that a newly

enraged Vanderbilt realized he had been gouged out of $7 million for what were essentially worthless pieces of paper. Other buyers were also cheated out of millions.

While Vanderbilt was waging war using the brute strength of his fortune, the Erie Ring, particularly Gould, were waging war on another level, a fact that Vanderbilt realized only in the aftermath of battle. Because most of his fortune was tied up in New York Central stock, he had to borrow funds in order to maintain his stock-cornering strategy. When the trading day was over, Gould and Drew withdrew all of the proceeds of the stock sales and locked them up in the Erie office safe. This sudden contraction of liquid funds at a critical time had the effect of raising short-term interest rates, making it more expensive for Vanderbilt to borrow additional capital. Vanderbilt quickly realized that the Erie Ring could not be defeated on Wall Street, and so he turned to the court system.

The next morning, warrants were issued for the arrests of Gould, Fisk and Drew. The three men were busy celebrating their victory at the Erie offices and counting the millions of dollars they reaped the day before. Somehow, word of their impending arrests reached them, and a plan was put in place to flee to Jersey City, out of Judge Barnard's jurisdiction. The trio raced for the border in a hackney coach bearing more than $6 million in cash and hundreds of thousands more in stocks and bonds. They also thought to pack up the papers and books of the Erie Railway to keep them from falling into the hands of Vanderbilt's lawyers and made plans to set up a new company headquarters at the Taylor Hotel.

When the shock of the battle was over, a suppressed panic set in on Wall Street. Vanderbilt sustained a fearful loss, and the least sign of faltering or lack of confidence could have triggered a stock market crash. He was holding 100,000 shares of Erie stock that he could never sell, and it was feared that even his great wealth could not withstand such a blow. The public watched Vanderbilt's every move and gesture as he mustered all available resources to maintain his positions in other railroads while counterattacking his foes. His nerve withstood the test, however, as he was seen playing whist at the Manhattan Club in the days that followed, reassuring investors that a stock panic was not imminent.

A few days after their flight, the three fugitives were sitting in their hotel room when a messenger told them that a band of toughs had come over from Manhattan and was collecting on the Long Dock and around the Erie Depot. Already naturally paranoid, Drew believed that Vanderbilt had sent the men to kidnap him and bring him back to New York. At first, Gould and

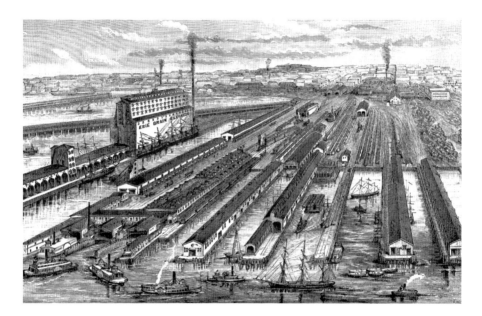

The new Erie Railway yard and dock at Jersey City served as a backdrop for what could have been a literal battle in the Great Erie War, complete with cannons, a "navy" and Erie workmen acting as "troops."

Fisk ridiculed Drew's rants, but soon they decided not to take any chances. Drew called Chief of Police Fowler and persuaded him to send fifteen men from the Jersey City police force to guard the approaches to Hotel Taylor. Then he summoned Inspector Masterson, general superintendent of police for the Erie Railway, who organized a force of Erie employees to patrol the depot dock and nearby streets. He even arranged to have three twelve-pound cannons mounted on the dock pointing toward the river. A small "navy" was organized in the form of four lifeboats manned by a dozen men each and armed with Springfield rifles. Detectives were sent to watch the ferry terminals on both sides of the river, acting as scouts to warn of any advances by the enemy. Hotel Taylor soon became known in the press as "Fort Taylor." The Great Erie War was beginning to resemble a war in the strictest sense.

Whether the "toughs" gathering at the dock were sent by Vanderbilt or not is unknown, but the attack Drew feared never came. The trio planned its next move. First, the men persuaded the New Jersey legislature to approve the incorporation of the Erie in that state, allowing them to operate legally. Then they began to work on getting back into New York. If they could somehow persuade the New York legislature to pass an act that legalized their

## The Great Erie War

fraudulent stock issues, the orders of Judge Barnard would be overruled. Their first attempt was defeated in the legislature by a vote of eighty-three to thirty-two.

Undaunted, Gould reportedly stuffed $500,000 into a satchel and, giving out the story that he was heading to Ohio on company business, secreted into Albany and sought out legislators who could be bribed into changing their vote. Despite the ruse, he was discovered soon after checking into the Delavan House and arrested. Erastus Corning, an opponent of Vanderbilt's in the New York Central wars, posted bail for his appearance in Judge Barnard's courtroom in New York City. Gould appeared in court a few days later but obtained a postponement of any actions by feigning illness. Losing little time, he raced back to Albany and met with as many legislators as would agree to see him. He succeeded in bribing several of them to vote his way, especially those who hailed from the southern tier of towns through which the Erie operated.

Even without the persuasion of Gould's greenbacks, support for the Erie bill was strong in the legislature and the public at large. Erie attorneys argued that the $10 million bond issue was voted on by the board to upgrade infrastructure and that it was within the executive committee's rights to raise that money in any way it saw fit, whether through bond sales or stock sales once the bonds were converted. The public at large was fearful of the consequences of a Vanderbilt takeover. Despite his reassurances to the contrary, the press warned that a Vanderbilt monopoly on New York railroads would result in much higher passenger fares and freight charges in the long-term. The *New York Herald* cautioned, "Anyone who remembers how Vanderbilt used to manage his steamboats, or who looks at the miserable cars, worn out tracks, and scanty train accommodations which now characterize the Hudson River, Harlem, and New York Central railroads under his administration, can judge what the fate would be if the sole obstacle to the full gratification of his economical propensities presented by the competition of the Erie road were removed."

The entire episode attained almost mythical proportions as newspapers around the country eagerly reported every detail of the unprecedented ransacking of Erie finances; the Wall Street manipulations; the battle with Vanderbilt; the flight of Gould, Fisk and Drew to New Jersey; and the continued corruption of the legislature. An investigating committee was appointed to determine what laws had been broken and by whom. According to Drew's own testimony, $500,000 was withdrawn from the Erie account for "legal purposes," but he could not show any vouchers that proved where the

money was spent. The committee reported that "large sums of money were expended for corrupt purposes by parties interested in legislation concerning railways during the session of 1868." However, the committee could not prove who did the bribing and which legislators received the bribes. It was only proven that lobbyist Lou Payne received $10,000 "for a few days' services in Albany in advocating the Erie bill" and that lobbyists Luther Caldwell and Russell Hicks received $100,000 to "influence legislation." A subsequent investigation revealed that the Erie spent more than $1 million on "extra and legal services" for which there were no receipts or accounting. The *New York Independent* called the current legislature "the worst assemblage of official thieves that ever disgraced the Capitol of the Empire State." The following essay appeared in *The Nation*:

> *For weeks past column after column of all the daily papers has been filled with the details of the "Great Erie War;" half the judges of half the courts of the city, county, and even the State of New York have been busy issuing attachments, certiorari writs, mandamuses, orders to show cause, and all sorts of other frightful weapons of offence and defense drawn from the musty arsenals of law; the Legislatures and Senates of two states have hurried with railroad speed and recklessness into passing laws suited to the occasion or to the wants and wishes of whoever had their sympathy; quiet rural towns in New Jersey have been startled by the din of war; millions of money have been carried out of the city and state to "places of safety;" a large part of the business of the city has been brought to a standstill; hundreds of millions in property have been depreciated five and ten percent in one week; and the Government of the United States has had to interfere to prevent a bank panic.*

Despite the controversy, Gould managed to stay out of prison while lobbying to get his 100,000 sheets of paper legalized by the legislature. He was aided by an odd incident involving an honest but aged assemblyman named Elijah Glen of Wayne County. On April 1, Glen rose from his seat and declared that he had been offered a $500 bribe for his vote on the Erie bill. It turned out that he was a victim of an April Fools' joke and never received a bribe after all. The assembly passed a vote of censure on their unfortunate colleague, who promptly resigned. The sideshow diverted attention from the bill at hand, enabling those who really did accept bribes to quietly legalize the entire issue of convertible bonds. The action was described by Judge Barnard as resembling a measure to legalize counterfeit money.

## The Great Erie War

A depiction of the guard room at the Taylor Hotel as Gould, Fisk and Drew waited tensely behind closed doors for an attack to come at any moment.

But Vanderbilt was not so easily defeated and began to file a litany of civil lawsuits in New York in addition to obtaining a ruling that held the trio in contempt of court. He demanded that the Erie Railway buy back all of the illegally issued shares at the price he paid.

Gould and Fisk were prepared to hold out indefinitely, but Drew missed his home and could not bear to be away from Manhattan much longer. After the fight went on for several months, Drew offered a compromise. Vanderbilt was paid $2.5 million in cash for fifty thousand Erie shares, $1.25 million in bonds of the Boston, Hartford and Erie Railroad, and another $1 million for the privilege of calling on the remaining fifty thousand Erie shares within the next four months. All of these funds were taken from the Erie treasury. Although the settlement left him with losses totaling about $2 million, Vanderbilt consented to abandon his lawsuits, leaving Gould, Fisk and Drew free to return to New York. As the final negotiation meeting at Vanderbilt's mansion came to an end, Drew later recalled Vanderbilt's parting words:

> *Drew, I dare say you will chuckle a heap, with that hen-cackle of yours, over this thing which you call a victory. Most likely you'll tell all your*

*friends how you downed the Commodore. Well, I don't know but you have downed me, after a fashion. But I don't want you to think it was because I didn't have money enough. If I wanted to, I think I could raise the cash to buy your crowd, body and breeches. But I confess that I haven't enough to buy that printing press of yours. In the present state of our country's jurisprudence, there doesn't seem to be any limit to the amount of stock certificates that you fellows can manufacture out of white paper. I'm willing to own up, Drew, that here's a case where you fooled me. Good night.*

And with that, the Great Erie War was over. Part of the deal stipulated that Drew would keep his profits from the stock battle in exchange for his removal from the Erie Board. Gould was named president and treasurer, while Fisk was named vice-president and controller. More stock-watering operations were carried out, causing stockholders to protest and threaten the pair with expulsion from the board at the next Erie meeting. Again Gould and Fisk boldly sought out the legislature, this time to enact the so-called Classification Act, which stated that only one-fifth of the board of directors could be retired in any one year. This made it impossible to wrest possession of the railroad in less than five years. To prevent large stockholders from taking control through the courts, another ridiculous act was passed that stated that only the attorney general of the state had the power to bring suit in court to oust the board of directors. It was thus only necessary for Gould and Fisk to "own" the attorney general through bribery and other influences. They followed up this triumph with a staged lawsuit in which a receiver was appointed for stock owned by foreign stockholders. Thereafter, when any foreign-owned Erie stock was presented for record in the transfer book of the Erie Railway, the receiver seized it. In this way, Gould took possession of $6 million out of $50 million in stock held overseas.

Gould then made William Tweed a director on the Erie Board and paid him handsomely to influence legislation. Judge Barnard, who was previously used by Vanderbilt to issue judgments against Gould, was a close associate of Tweed's and thereby became an ally of Gould's, most famously in the Albany and Susquehanna Railroad war. Judge Barnard was so beholden to the Erie Ring that he reportedly once held court at the apartment of Josie Mansfield, Fisk's mistress. On another occasion, Gould called on Barnard at his house and obtained an injunction while he was eating breakfast. During the 1873 assembly committee investigation, Gould admitted that during the previous three years he paid large sums of money to Tweed and others "which might have been used to influence legislation or elections." These

sums were charged on the Erie books to an account called the "India Rubber Account," no doubt an inside joke to Gould and Fisk.

With Drew out of the picture, Gould and Fisk were able to enrich themselves as never before by using the usual methods: Wall Street corners, raiding trust funds, manipulation of the legislature and a vast tangle of injunctions and lawsuits in various city and country courts. Gould was able to carry out such frauds by shrewdly appealing to the public's fear of monopolies. By representing himself as the only person between Cornelius Vanderbilt and the hijacking of the entire railroad system of New York, he maintained a distinct edge over Vanderbilt in the court of public opinion, which in some ways was as strong as any judicial court. Small manufacturers also bore deep-seated feelings against Vanderbilt due to the perception that preferential freight rates were given to certain wealthy businessmen. Rumors abounded that special freight trains were purposefully delayed and run slowly in order to force shippers to pay higher rates using the Merchant's Dispatch, a fast freight line operated by the New York Central. The agricultural classes were likewise disaffected. For example, farmers were charged half of what they received for milk, leaving little for profit. Small businesses and farmers feared that if Vanderbilt controlled all of the lines leading from New York City, he could essentially set whatever rates he wanted and all would be forced to pay them.

Small stockholders were placated by the promise of slightly larger dividends than they were getting under the former leadership. Gould accomplished the seemingly impossible task of paying out dividends from the cash-strapped railroad by issuing bonds and paying dividends out of the proceeds. So long as investors received a return on their investment, they were content to let Gould do as he pleased despite the steady stream of bad press and fraud investigations.

Even after his unceremonious exit from the Erie Board, Daniel Drew could not seem to stay away from the action. In the fall of 1868, rumors were circulating that the railroad was about to go bankrupt and once again be put under the control of a receiver. Gould increased the common stock outstanding from $38 million at the beginning of October to nearly $58 million three weeks later, making it more difficult than ever to maintain a decent per-share stock price. Drew took the opportunity to sell the stock heavily short, resulting in a price drop that settled at about thirty-five. The annual fall crop season, with all of its extra currency demands, left less cash in open circulation, forcing down the market as a whole. Several English investors put further pressure on Erie when they began selling large blocks of stock.

Sensing Drew's actions, Gould and Fisk quietly began buying up shares. They were aided by fortunate timing—the stock sent over the Atlantic by English capitalists to sell was not as numerous as some they feared, and more wouldn't arrive until the next boat came two weeks later. The stock price began to stabilize and then rise. When some of the short sale contracts came due in mid-November, the price jumped to fifty-two.

Drew was caught once again on the wrong side of the stock market. He knew that he would have to make a humiliating visit to Gould and appeal for mercy, but first he attended a meeting of the "bears" led by August Belmont, who represented several foreign shareholders. There he learned that the group was preparing an injunction to put the Erie into the hands of a receiver. When he met with Gould and Fisk that Sunday evening at Erie headquarters, he said that the opposition was working on a scheme to overthrow the Gould management, but if Fisk and Gould would save him from personal loss, he would reveal the details of the plan—otherwise he would join forces with their enemies. Fisk declared that this was just another one of his old tricks and that Drew was "the last man who should whine at any position he had put himself in with regard to the Erie." A mixture of pleading, reasoning and threats did nothing to sway his former partners, and Drew left in dejection.

The following morning, Belmont obtained an order from Judge Sutherland that restrained any further stock issues or the removal of any more funds from the Erie treasury. Using information given to them by Drew as he was pleading for mercy, Gould obtained an order from his new friend Judge Barnard, who authorized him to purchase 200,000 shares of Erie stock at any price below par. Defying Judge Sutherland's order, Gould continued purchasing stock until the price was bid up to sixty-one.

One small but well-timed event saved Drew from absolute ruin. About 300,000 shares of Erie stock—which Gould believed were either in England or on their way to America by boat—were actually owned by hundreds of local citizens in ten-share certificates. The artificially high price of the stock brought a multitude of merchants, laborers and small investors scurrying to Wall Street to sell their shares. The price soon dropped to forty-two, although the bears forced it back up to forty-seven as they covered their short contracts. Drew and his party were able to settle at about twenty points above their purchases, realizing a loss of $1.25 million but leaving him with enough money to survive and fight another day.

Considering the blatant ransacking of the Erie by Gould and Fisk at the expense of thousands of investors, it is quite surprising (and a testament to

their extraordinary gifts, no matter how unscrupulously they used them) that they lasted as long as they did. The first blow to the unholy alliance came when Fisk was murdered by a rival for his mistress in January 1872, leaving Gould to face his enemies alone.

The final straw came when Gould himself was tricked out of over a million dollars of Erie funds. An Englishman who called himself Lord Gordon Gordon arrived in New York City purporting to be the representative of the British bondholders of the Erie Railway. He claimed that these bondholders were hostile to Gould and his future plans for the railroad and that they had sent him to investigate the company on their behalf. The first interview between the two resulted in Gould being abruptly shown the door by the apparently insulted aristocrat. After Gould apologized, he gave Lord Gordon Gordon several million dollars in negotiable securities as evidence of good faith in a transaction whereby the British investors were to be outwitted by their supposed agent, with Gould's assistance. It was soon found that the "Lord" was a fraud with no royal connections. He lost little time escaping to Canada with Gould hot on his trail. An international incident was barely averted when Gould attempted to kidnap Gordon and bring him back to the States for trial. The ordeal ended with Gordon's suicide in Canada. It wasn't long after this shocking event that several English investors decided once and for all to remove Gould from the board no matter how much it cost or what methods were used.

General Daniel Sickles, one of the heroes of Gettysburg and minister to Spain, was engaged by these English capitalists to lead the fight. This time, they were smart enough to bypass the legislature and simply bribe the Erie Board to resign using $750,000 that was raised for just that purpose. Additional sums, taken from the Erie treasury, were expended in bribing legislators to repeal the Classification Act.

The final blow was struck at a board of directors meeting held on March 11, 1872. In a conciliatory gesture, Gould allowed a man named Oliver Archer to become the vice-president in place of Fisk. Nine members were successfully "turned" into an anti-Gould coalition and aligned themselves with such stakeholders as Major General John Dix (who was later elected state governor), General George McClellan, William Travers of the Saratoga Raceway and Henry Stebbins, former president of the New York Stock Exchange. The board wrote to Gould and asked him to call a meeting. When he didn't respond, Archer used his powers as vice-president to call the meeting. The nine "revolutionaries" and their allies prepared to storm the Grand Opera House, where the Erie offices were located, to take control of

the books. Gould had the building secured by his men with instructions to let no one pass, but the coalition men brought "troops" of their own and succeeded in forcing their way in, whereupon the last Erie war was fought in an extraordinary scene that lasted all night.

After ordering the faction to leave and getting a negative response, Gould called on his attorney, Thomas Shearman, who arrived with forty policemen. Shearman reiterated Gould's order to leave, but the revolutionaries shut themselves in their rooms and again refused. Gould obtained a temporary injunction from Judge Ingraham to restrain Archer and the other directors from taking any action, but they calmly ignored the order and elected General Dix as president and installed new officers and directors. A local newspaper described the memorable night: "Gould and his counsel were in one room and the newly chosen directors were in another, the doors of both rooms barred, each fearful of orders of arrests being served on them, and an intense sense of subdued excitement pervaded the heavy air of the place."

The Dix forces were bolstered by the arrival of United States marshals, who attempted to serve Gould with court orders to surrender the Erie books. Finding Gould barricaded in his office, a crowbar was produced, the door was wrenched open and a phalanx of marshals poured in and swept away all opposition. An almost comical scene unfolded as a deputy marshal approached Gould with an outstretched hand clutching court papers. Since all exits were blocked, Gould rushed around the room in a desperate game of tag, throwing chairs behind him in an effort to slow down his pursuer. The game finally ended with Gould being gang-tackled and pinned to the ground. The panting deputy reached out, shoved the papers into the breast of Gould's coat and shouted triumphantly, "You are served!"

Incredibly, Gould still refused to give up. With most of the building in possession of the Dix faction, he retreated to the telegraph office and sent out messages to all parts of the Erie that he was still in control and that no other authority should be recognized. He then sent one of his attorneys to the office occupied by the new board of directors to serve court papers of his own. Another attorney counseled that Gould's position was "legally impregnable" and urged him to gather his forces and attack the directors' room. Gould almost gave the order, but with more than one hundred strong-arms supporting his enemies, he thought better of it. At one point, there was rumor of a coming attack, and the marshals in the directors' office hurriedly barricaded the door. Upon hearing the commotion, the Gould faction

# The Great Erie War

When Jay Gould was finally stripped of power and expelled from the Erie Railway, many celebrated the fall of the "Erie Ring." However, Gould's career was far from finished as he soon turned his attentions to western railroads, the elevated railroads of Manhattan and telegraph companies. *Library of Congress.*

assumed that the other side was about to attack and likewise barricaded the other side of the same door.

As the night dragged on, the two sides began negotiations through General Sickles. It finally became clear to Gould that his enemies had all the advantages of thorough preparation, court orders, deep pockets and support from the majority of Erie stockholders and the public. He sent an acknowledgment of defeat to the new board and agreed to step down.

Gould's troubles didn't end once he departed the Erie Board for good. First he received word that two of his faithful allies, Judges Barnard and Cardozo, were recommended for impeachment by the Judiciary Committee of the Assembly. Cardozo immediately resigned, while Barnard had to be formally removed from office.

Next, a lawsuit was instigated from a member of his own brokerage firm. Gould continued to dabble in the stock market in spite of his troubles and became interested in the stock of the Chicago and Northwestern Railroad.

Henry Smith, a partner in the firm of Smith, Gould and Martin, thought he was shorting the stock and therefore entered into several short contracts. Instead, Gould cornered the stock by purchasing every share that was available and pushed the price from 75 to 250. He then sold most of the shares at 250 and reaped huge profits. Seeking revenge, Smith handed over his firm's books to General Barlow, counsel for the stockholders who brought suit against the Erie. Within the books was ample evidence of the thefts and frauds that Gould perpetrated over a number of years. An action was commenced to have him arrested and force him to return $12.8 million, representing the proceeds of bonds converted into 407,000 shares of stock that were sold but never reported.

Gould was trapped, but once again his remarkable cunning rescued him. He knew that as soon as he agreed to restitution, the value of Erie stock would immediately rise and numerous new buyers would appear. He secretly purchased as much Erie stock as he could get before publicly declaring his intention to make full restitution to the railroad. As expected, the stock price skyrocketed as his brokers sold it all back to the market at high profit. The stockholders agreed to his offer to surrender control of the Erie and accept real estate and stocks that had a par value of $6 million. However, once the lawsuits were dropped, they realized that the property was worth no more than $200,000. Gould held on to $500,000 worth of Erie bonds that he later exchanged for the title deed of the Grand Opera House, which he gave to his son as a gift.

When the smoke cleared from the many battles over the Erie Railway, it was estimated that Gould had personally benefited from various schemes in the amount of $12 million in cash, but even this large number was later considered to be a gross understatement. A final accounting found that Erie debts increased by $64 million during Gould's tenure, little of which was used to buy new equipment or build infrastructure. Although it was one of the most important transportation systems in the country and shipped more freight in most years than the New York Central, the Erie Railway was severely crippled by its enormous stock and bond obligations. Even as late as 1895, the railroad was saddled with $85 million in debt that required more than $5 million in annual interest charges. The Erie wars were at an end, but thousands who invested their hard-earned money into Erie stock continued to pay the price of those wars for many years to come.

# Labor Wars

The railroad employee of the mid- to late 1800s often had reason to be bitter toward his employer. The days were long, work was hard and the pay was meager. Many of the railroad wars described in previous chapters adversely affected not only the public at large but also the very men who kept the trains running. When a railroad's capitalization was "watered" by bogus stock, the company was forced to pay out more in dividends, limiting what could be spent on salaries. Fare wars had the same impact—profits declined, followed by employee wages. Meanwhile, the railroad owners regularly made headlines with their stock manipulations, treasury plundering and lavish lifestyles.

Organized labor on a national scale first made its appearance in the wake of the Industrial Revolution when the rise of large factories forced hundreds of people to work together under one roof. The often deplorable conditions of the early textile and steel mills led to the first efforts to organize labor so that many workers could speak with one voice for better working conditions.

A business recession in 1857 severely weakened the union movement, further exacerbated by the outbreak of the Civil War, which drew hundreds of thousands of men away from the workforce and onto the battlefields. During the 1870s and 1880s, union membership mushroomed as the Knights of Labor became a powerful workers' lobby and a thorn in the side of big business.

For many years after the formation of the first labor union, there were no large-scale work stoppages that affected whole industries, especially in the railroad world. Instead, there were many small strikes that impeded traffic

or held up construction. The *Troy Whig* recorded a strike of 150 laborers on the Troy and Schenectady Railroad just before Christmas 1841 that resulted in a riot and the formation of an armed posse. Most worker strikes, however, lasted only a few hours and were quickly settled without much disruption of service or damage to property. The greatest unrest of the 1860s occurred when the railroads attempted to introduce the concept of piecework in which men were paid according to the runs they made rather than time on the job. A brief strike at the Erie Railway machine shops in 1874 resulted when the treasury plundering of Jay Gould left the railroad bankrupt and unable to pay its employees.

The Great Strike of 1877 was the largest and most destructive labor dispute in the nation's history until that time. The Panic of 1873 was followed by several years of general economic stagnation accompanied by falling prices and wages. There was finally a feeling that the hard times were over, and employees began to make demands for an increase in pay or at least the restoration of their former rates. It didn't help that working conditions were poor: hours were long, days or weeks were spent away from home and injuries were common. So when the railroads responded by cutting wages 10 percent, workers around the country were outraged. On the New York Central, engineer wages were cut from $3.50 per day to $3.15, fireman wages were cut from $1.75 to $1.58 and switchmen wages were cut from $40.00 per month to $36.00. Similar reductions occurred on the Erie Railway.

Wages and working conditions on the New York Central would be considered unacceptable by today's standards, but in the 1870s, they were higher than on many other railroads. A run of one hundred miles constituted a day's work for engineers, who received $3.50 per day for any amount of mileage up to one hundred. For every mile over the limit, they were paid 3.15 cents. Many engineers managed to travel 150 miles a day, six days a week and earn almost $123.00 per month. At the Erie, wages were even higher in an effort to appease employees who had to deal with more infrastructure problems than on other railroads. Engineers were paid 50 cents per day more than those of the New York Central, while firemen were paid 60 cents more. The higher wages were a factor in the relative peace during the strike compared to other railroad cities.

The widespread strike took the nation by surprise. At first, the wage reductions were grudgingly accepted, but gradually the simmering bitterness of the long hours and harsh conditions of working for the railroads began to boil over. Workers observed that the companies continued to pay dividends on stock at the same time they were claiming to be unable to pay prevailing

The rise of unions such as the Brotherhood of Locomotive Engineers set the stage for a series of national strikes during the late 1800s. *Library of Congress.*

wages. There was a general feeling of indignation at the perceived poor management and fraud by company officers who were only looking out for their own interests and those of the stockholders, leaving the workingman with barely enough earnings to survive. One Erie Railway brakeman summed up the sentiments of the striking railroaders:

> *When we complain that our wages are too small to support a comfortable life, they tell us that railroads do not exist to support us—that the managers are trustees of other people's property. Now, we can't help seeing that these managers, in spite of their conscientious devotion to the interests of the road-owners, have been wildly squandering this property, income, and assets in a crazy struggle to ruin one another. But it is still more irritating to see the money, which is whittled from our wages by these magnates, spent with open-handed liberality to gratify their own love of display and sumptuous pleasure. Our men are not profound or subtle thinkers, perhaps, but they keep both eyes wide open, and these things are exasperating.*

Hostilities began on the Baltimore and Ohio Railroad and spread rapidly over the northern railroads between the Mississippi River and New England, including the Pennsylvania Central, the Lake Shore and Michigan Southern, the Canada Southern, the New Jersey Central and the Illinois Central. Tracks at the principal junctions were blocked so that all freight trains and most passenger trains were prevented from moving. For several days, the entire internal commerce system was interrupted as more than 100,000 men joined the strike. State militias and federal troops were called out to restore peace and engaged in dozens of encounters with rioters that injured or killed hundreds. The greatest loss of life and destruction of property took place at Baltimore and Pittsburgh, but the violence soon spread to New York State, where thousands of employees joined the strike. Buffalo was particularly affected due to the large number of men who were employed at the shops and yards.

The Erie Railway was the first to feel the effects of the strike as it spread across the country. As early as July 20, firemen, brakemen and trackmen called a midnight meeting at Hornellsville (about sixty miles due south of Rochester) and voted to strike the next day. A committee was sent to notify the superintendent of their intentions; he then telegraphed headquarters in New York. In an effort to block more Erie employees from reaching Hornellsville to give support to the strike, all trains heading in that direction were stopped. The strikers demands included the reinstatement

# Labor Wars

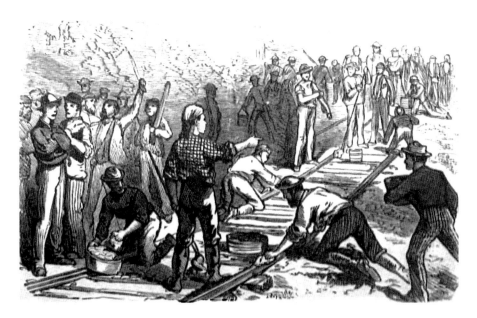

In order to keep trains from leaving town, strikers soaped the tracks at the slight upgrade out of Hornellsville.

of several discharged men, the restoration of wages to previous levels and the discontinuation of rents paid for company land occupied by employees except according to agreement.

Unlike other railroads, the primary grievance was the discharge of union committeemen who were fired when they presented several demands for better working conditions and the equitable promotion of engineers based on merit rather than by favoritism. The reduction of wages only applied to certain classes of employees who were not subject to a reduction the previous year and were therefore receiving higher wages than at other railroads.

When the company declined to abide by the terms, all trains were stopped by the strikers. A conference was again held in which the strikers gave their demands for returning to work. That evening, while having dinner at the Nicols House, the astonished leader of the strikers was arrested on a warrant issued by Judge Donohue of the state Supreme Court and taken to New York City. He was charged with contempt of court for interfering with Erie Railway property but released after serving a brief sentence.

Governor Robinson left his home in Elmira and made his way to Albany in the midst of widespread calls to put down the strikers and help open the road. He telegrammed Adjutant General Townsend to get each division

ready for service at a moment's notice. By the next day, more than three thousand men were equipped at the different state armories and prepared for deployment. He then issued a proclamation stating that any person who willfully destroyed railroad property or obstructed its free movement was subject to ten years in prison and up to $1,000 in fines. A reward of $500 was posted for the arrest and conviction of any person who violated the Act to Punish Trespassing on Railroads. The reward was perhaps more effective than the presence of the military, as strikers felt they had a price on their heads and could be betrayed by their comrades at any time.

Troops from the 54th Regiment of the New York State Militia from Rochester arrived at Hornellsville on July 21, followed by the 110th Battalion from Elmira with a field gun. A line was formed that marched through the rail yard and drove out the crowd while other troops guarded the approaches. The strikers met and decided to stay firm despite the arrival of troops.

The Erie announced that a train would leave that day, but the strikers resolved to stop it. Forty soldiers of the 110th Battalion were placed on the train: five in the locomotive, two on each car platform and the rest inside the cars. The rioters assembled at West Street, having first soaped the rails so that the locomotive could not gain traction. The soap was effective, and the train approached the crowd at no more than eight miles an hour. Screaming with fury, the crowd ordered it to stop with threats of violence. The engineer attempted to drive through the multitudes, but the small guard force was quickly overwhelmed. Guards on the cars were pushed aside, and men clambered aboard to apply the handbrakes. The engineer remained defiant, but the passenger cars were uncoupled and vandalized with axes and clubs. Then the cars were sent back down the grade toward the station they just left, threatening to destroy everything in their way, but the cars were turned off on a switch before colliding with a locomotive that sat on the track.

Next the crowd turned its attention to train no. 7, which had just started out of the yard toward Buffalo. A switch was thrown ahead of the locomotive, forcing the engineer to apply the brakes. The fireman was pulled from the engine and made to promise not to make another attempt to leave while the engineer was told to back up into the yard again.

Another gang of strikers boarded an engine and cars that were being switched onto the Susquehanna Division. The engineer and several deputy sheriffs were driven off, and the engine and cars were run onto the bridge a short distance east of the station where the steam was blown off and the fire was extinguished. During all of this activity, the hopelessly outnumbered

troops could only stand by and watch. They were later roundly criticized for doing little or nothing to confront lawbreakers and restore order.

Reacting to the violence, 1,500 troops of the Twenty-third Regiment of Brooklyn were called out and arrived the next day. They were insulted all along the route at each station, but when they arrived, the strikers knew that they could not resist such a force and agreed to the following terms: the firemen and brakemen agreed to the 10 percent pay cut, no men engaged in the strike would be discharged unless they damaged company property and the reinstatement of the discharged committee was left to the superintendent of the division in which the dismissals occurred.

Responding to a massive riot, another detachment of the Twenty-third Regiment arrived at Corning on July 24. As soon as the train stopped at the Corning station, a mob closed in and attempted to uncouple the locomotive, but the troops sprang from the cars with fixed bayonets and deployed to either side. Stopped on that front, the mob turned and made a rush for the railroad bridge a short distance west of the depot. Portions of the track were torn up and switches were spiked, rendering the bridge impassable. Rail workers not part of the strike unloaded the contents of the baggage, mail and express cars regardless of destination and stored it in the depot for safety. A telegram was received that the strikers had abandoned Hornellsville and were preparing to make Corning the new base of operations. Hearing this, the troops at Hornellsville boarded a train and headed for Corning. Along the way, they were hounded by a group of forty strikers that attempted to tear up the tracks both in front of and behind the train. At one point, the locomotive was thrown off the track by the removal of rail spikes, forcing the troops to march the rest of the way.

The most serious riots on the New York Central occurred at Buffalo, the western terminus of the New York Central and a hub for two other striking railroads—the Lake Shore and Michigan Southern and the Erie Railway. Unlike the geographic layout of the shops and yards at Albany, which were based a mile away at West Albany or across the river in East Albany, the city of Buffalo had to endure the full fury of the strike because most of the shops and tracks were embedded within city streets. Forty or fifty firemen began agitating for a strike on Saturday, July 21, but it wasn't until the following day that a general strike was called that involved 1,500 men. Early in the morning, they compelled all the brakemen and firemen to get off their trains and stop working. The huge mob became reinforced with members of the general public and swarmed into the car shops of the Lake Shore and the Erie railroads and ordered all the men there to quit work as well.

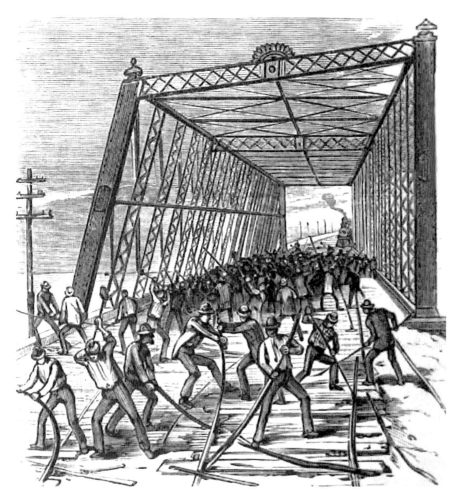

Strikers at Corning tore up the tracks approaching the bridge out of town, rendering it impassable.

A strange exchange occurred at Compromise Crossing two miles from the Erie depot. A Buffalo and Jamestown train was stopped by the strikers and had its passenger coach detached and shoved onto the Central track. The fireman was forcibly taken from the engine. Superintendent Doyle, who was on the train, rushed to the engine and scolded the strikers, saying that there had been no pay reduction on their road and never was since its inauguration. Upon hearing this, the strikers brought the coach back to the train and coupled on, assuring Doyle that nothing would be done to interfere with his railroad.

In some cities, all trains were stopped by the strikers, but at Buffalo there was a deliberate effort to stop freight trains only and allow the U.S. mail and passenger trains through. The reason for this was twofold. If the U.S. mail was stopped, there was a risk that federal troops would be called out to ensure that mail cars were unmolested. Fighting a local militia was one thing, but fighting against well-trained and equipped federal troops was something else entirely. There was also a desire to avoid alienating the traveling public. One striker told the *Buffalo Express*, "We know that we have the sympathy of the public so long as we do not interfere with the passenger trains, but as soon as we stop passengers they begin to grumble and in this way they hurt our cause."

The most intense activity took place at the Lake Shore roundhouse on Scott Street. In the afternoon, two hundred soldiers guarding the roundhouse were overwhelmed by a mob of two thousand rioters. They were forced to leave the building, which was then barricaded with rail cars placed into defensive positions. Colonel Flach of the Sixty-fifth Regiment tried to retake the roundhouse by forcing his way through the crowd with bayonets but was met with clubs, knives and a shower of stones. Flach himself was knocked down twice and forced to take refuge in the paint shop. The violence continued when a train coming from Westfield on the Lake Shore Railroad was boarded and forced to stop. A fight ensued with soldiers of the Eighth Division who were on board.

There were several instances when violence seemed inevitable, but the militia and local police were credited with displaying restraint in the face of multiple acts of vandalism, insults and stone throwing by the mobs. On Sunday evening, police arrested a man near the roundhouse and moved him toward the precinct jailhouse. The police and their prisoner were followed by a boisterous mob that made several attempts to free the man from custody. As they neared the jail, stones were hurled at the police, some of whom were hit and badly cut, causing them to draw their revolvers. They held their fire, however, and managed to get their prisoner to the jail before returning to the roundhouse.

Another incident took place the following morning. Several hundred strikers descended on the roundhouse armed with clubs and stones and compelled all of the workers there to leave. Then they headed toward the machine shops, converging on a line of soldiers from the state militia guarding employees who wanted to continue working. The huge crowd pushed its way past the astonished militia members, who briefly began to ready their weapons but then thought better of it.

The Erie Railway's Corning Station witnessed some of the most violent demonstrations during the 1877 workers' strike. *Library of Congress.*

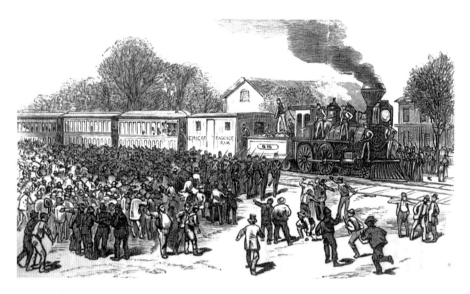

Troops had to be called in to break up riots in several cities and towns during the 1877 strike. Pictured is the Twenty-third Regiment at Corning, where it was met by an overwhelming force of rioters.

## Labor Wars

The remarkable restraint of the authorities came to an end Monday afternoon as the mobs began to take advantage of the inaction on the part of the militia. Word reached Buffalo that another company from Westfield would arrive by train soon after dark to reinforce the outnumbered soldiers already deployed. A crowd of about three hundred lay in wait at the Buffalo Creek bridge. When the troop train arrived, the mob forced it to stop at the bridge and demanded that the militia company give up its arms before proceeding to Buffalo. The commanding officer refused. While he was talking to several of the strikers, others crept into the rear of one of the cars and began forcing some of the soldiers to give up their weapons at gunpoint. When the commander saw what was happening, he furiously gave the order to "clear the car." Several soldiers reacted by opening fire on the strikers, who in turn fired guns and threw rocks through the doors and windows of the cars. At the sound of gunfire, the soldiers in the rest of the cars opened fire at will, sending a volley of dozens of rounds at the now fleeing mob. When the smoke cleared and paramedics arrived, it was found that ten people from the crowd were wounded and one was killed. Two soldiers were also wounded in the melee.

News of the shootings quickly spread across Buffalo. Angry citizens set fire to one of the cars used to bring in the militia while it was parked outside the roundhouse. When a fire company arrived at the scene, the crowd would not allow it to put out the blaze. Then they tried to push the burning car into the roundhouse to set it on fire, but some of the railroad workers protested that it was their place of employment and prevented the car from being moved.

The city endured another frightful day on Tuesday as mobs armed with clubs continued to roam the streets. Several groups of strikers and sympathizers traveled from one factory to another throughout the city to either ask or force the workers to join the strike. At some places the workers complied, but at others they resisted or were protected by growing police and militia forces. A group appeared at the New York Central's Niagara grain elevator on the waterfront and demanded the men quit work, to which the men at the elevator responded that they were satisfied with their wages. The workers continued to load grain onto canalboats, although no railroad cars were available for loading as was usually the case.

In the evening, a large crowd gathered at Exchange Street near the New York Central and Erie Railroad depots. The militia assigned to patrol this section of the city, which contained some of the city's largest manufacturing establishments, tried to control the crowd but was overwhelmed. The city

police, however, decided to clear the street by charging into the middle of the crowd, which offered little opposition and began to disperse. At the same time, a separate mob of five hundred stormed through the main doors of the Central's car shops and forced the militia housed there to flee out the back.

By Wednesday, much of the fury of the mobs had been spent. In the morning, a large crowd marched to the Haines lumberyard and attempted to drive away the employees. The police intervened and arrested several people. Two hours later, the crowd tried again. This time the police charged with batons swinging, arresting over a dozen and scattering the crowd in all directions. A few more strikers were arrested on Thursday, but there were far fewer demonstrations as the police and militia solidified their command of all major streets. The strike was finally declared over that evening.

Several classes of workers also went out on strike in Albany, although there was little destruction of property or violence. The New York Central's primary shops and freight yards for the entire railroad were located in West Albany, employing about 1,500, while several roundhouses and sorting yards of other railroads were located across the Hudson River in East Albany. On July 25, a morning meeting took place at Albany's Capitol Park where union members agreed to ask for a 25 percent increase in wages. A committee was appointed to wait on William Vanderbilt, who had recently attained the presidency of the railroad upon the death of his father. The two parties met the next morning, but Vanderbilt informed them that the 10 percent wage reduction was necessary in light of the continuing economic troubles.

Upon hearing that a strike was called, a crowd marched for West Albany and persuaded four hundred employees to quit work. Some joined the strikers, while others simply went home to wait out the unrest. A mixed train arriving in West Albany had its freight cars detached and run off into a siding, while the passenger cars were allowed to proceed. At that point, the strike was limited to the machinists, painters, blacksmiths, carpenters and others who were employed at the shops, while few railroad men took part.

Another meeting was held in the afternoon, where a letter was read from William Vanderbilt asking the men to remain at work until the "excitement" was over, at which time a "fair conference" would take place. The men jeered, one of them calling for whatever action was necessary to stop the trains from moving until Vanderbilt gave in to their demands. About one thousand men then started for Greenbush and East Albany, taking over the freight house on Water Street and compelling the workmen there to leave. The strikers made their way to the roundhouse and elevator before surging across the

railroad bridge spanning the Hudson River. This bridge was used almost exclusively for freight traffic, so the tracks were spiked on the Greenbush side. Meanwhile, a gang of young men stoned a passenger train at the Van Woert Street crossing, but no one was hurt and they quickly fled at the sight of approaching police deputies.

Later in the evening, the Ninth Regiment from New York arrived by train and marched to the Delevan House with fixed bayonets. The sight of the soldiers in formation settled the crowd. The next morning, the troops were sent to West Albany, where General Carr set up headquarters at the railway station. The excitement from the day before had dissipated—most strikers spent the afternoon sitting on either side of the railroad tracks approaching West Albany while their wives and children brought them meals and news of the strike from other cities. Some of the workmen who were forced to leave the previous day came back to work under military guard. The Tenth Regiment of Albany arrived to defend the yard approaches so that a few trains could leave.

The strike came to an end in Albany on July 26 with the arrest of John van Hoesen and Charles Lyons for interfering with trains and inciting a riot. It was revealed that Van Hoesen made an inflammatory speech at the Capitol Park meeting and later led a small group of men in tearing up a section of track at Greenbush. He was taken to Troy to await the action of the grand jury. Lyons was released due to a lack of evidence.

The reluctance on the part of the strikers to damage property in Albany was rooted in the fear of what would happen if the shops were burned down either purposefully or otherwise. It was well known that the shops and yards were established at West Albany just after the formation of the New York Central by then president Erastus Corning. It was whispered that if anything were to happen to the shops, the Vanderbilts would rebuild at a more convenient location.

Similar activities were observed in Syracuse, although the lack of major rail facilities in the city limited the scope of the strike to a few days. The railroad men blocked all trains on July 21 and voted to strike the next day. The Fifty-fourth Regiment was called out to duty, but there was no violence reported against any railroad property other than what was necessary to stop the trains. Within twenty-four hours, the strikers had stopped forty trains consisting of six hundred freight cars. In the evening, a livestock train arrived from the west and pushed into the yard without slowing down. The strikers seized a yard switcher and gave chase, overtaking the train about six miles from Syracuse and ordering the fireman to come back with them to the yard.

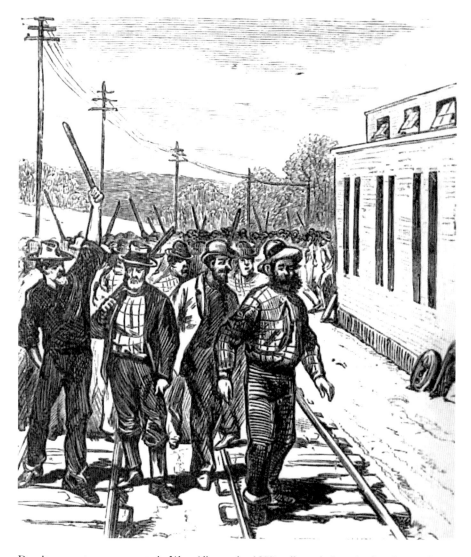

Despite some tense moments in West Albany, the 1877 strike only lasted a few days and featured little destruction of property.

Both the Fifty-fourth Regiment and the Eighth New York Regiment were called in to quell the mob, and order was quickly restored.

Downtown Syracuse was relatively peaceful compared to the violence and destruction of property that took place in Buffalo. The railroad workers who actually went on strike worked in East Syracuse, five miles from the city, and did not welcome the "interference" of others who

wanted to join them. Railroad shop workers from the Fifth Ward in Syracuse never went on strike, sparing the city itself from roving mobs and demonstrations. Additionally, with trains stopped at Buffalo and Albany, the two main gateways of the New York Central, there were few trains passing through Syracuse during the height of the strike.

The Great Strike of 1877 was largely over by July 30, when all the trunk lines declared that traffic had attained former levels. The strike on the New York Central was over far sooner, since some classes of railroad workers refused to join in the first place. William Vanderbilt promised to restore the wage cuts as soon as economic conditions warranted it and in the meantime paid out $100,000 in bonuses to the employees out of his own pocket. Workers on the Erie Railway went back to work on July 27, with the only stipulation that the labor committee members who had been discharged be given a fair hearing.

Overall, the strike was considered a defeat for organized labor. Public opinion turned against the strikers once the full details of the bloodshed and vandalism in some cities were revealed. It would be years before another significant strike occurred, especially in New York State, although there were several small ones of little consequence. For example, a freight handlers strike centering in New York City, in which employees of the New York Central and Erie Railroads demanded an advance from seventeen cents an hour to twenty cents, collapsed after a few days when the railroads quickly hired enough strikebreakers to resume freight operations. Eighty switchmen on the New York Central went on strike in 1888 demanding an increase from forty to forty-five dollars per month and extra pay for overtime. A compromise was worked out the next day. In 1889, conductors, switchmen and brakemen quit work because a conductor had been discharged for a rule infraction. A hasty investigation found that the conductor was fired in error, and he was returned to work. A similar incident occurred that year in Buffalo on the Erie Railway when seventy switchmen went on strike to protest the discharge of three of their fellow workers. The company insisted that they had been discharged for cause and began hiring new switchmen to take the places of the strikers. Meanwhile, in Oswego, fifty brakemen of the Rome, Watertown and Ogdensburgh Railroad went on strike because they claimed to be working overtime without pay. After a few days of intense negotiations, the brakemen returned to work on the company's terms.

Although the 1877 strike was one of the largest for the country as a whole, a railroad strike that took place in 1890 was far worse for the state of New York in terms of damage and violence. During the month of July, seventy-eight men

were discharged for "good and sufficient cause," according to New York Central management. It just so happened that all of the discharged men were members of the Knights of Labor who were one-time officers of the order or served on committees that had presented grievances to the company. The Knights came to the conclusion that "it was only a question of time when they would one and all be discharged unless they forfeited their manhood and abandoned their privileges by renouncing their right to join in an organization to protect their just rights" and demanded that the men be reinstated to their former positions. Management refused, and a strike was called on the Central's Hudson Division and the Harlem Railroad on August 8.

The first to leave their posts were the switchmen at the Grand Central yard in New York City, tying up Grand Central Station and most of the rest of Manhattan. The only train permitted to leave that day was delivering U.S. mail. By nightfall, all the engineers, brakemen, conductors and trainmen had joined the strike. Vice-President Webb stayed up all night arranging for replacement workers to be brought in from parts of the Central's western lines, while the West Shore division was geared up to handle the increased traffic.

Within a few days, five thousand workers between New York and Buffalo had quit work, tying up nearly all freight trains. Although there was very little outright violence or destruction of property, Webb and other managers decided that local authorities would not be sufficient to quell the mobs and safeguard those who wanted to remain working. They were determined to break the strike at all costs and immediately began recruiting new employees to fill the vacated positions. In order to ensure that these new employees would not be molested, Webb also made the fateful decision to bring in a force of Pinkerton detectives to aid the Albany police department. The Pinkerton Detective Agency was formed in 1850 to counteract the growing power of the labor unions by infiltrating their ranks and providing protection to those who crossed the picket lines, but the public was largely distrustful of the company.

Tensions came to a head on August 16 at the Van Woert Street crossing near West Albany. Crowds began to gather in the early morning hours, but everything was quiet until 1:00 p.m. Suddenly, a freight train came down the tracks from West Albany bearing two Pinkerton men atop each car brandishing repeating rifles. Several people in the mob threw stones at the train, prompting one of the detectives to open fire. A boy named Richard Dwyer was hit in the thigh and fell to the ground. A mob rushed the train and managed to capture the detective, dragging him toward a nearby tree as if to carry out a lynching. He was saved from certain injury

## Labor Wars

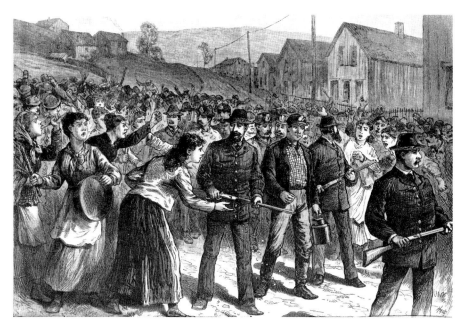

The Pinkerton Detective Agency was sometimes hired by railroad companies to act as guards for strikebreakers, but in most of the New York State–based strikes, its strong-arm tactics incited more violence.

by the quick action of the police, who charged into the melee and took him into custody.

At 3:00 p.m., a freight train bound for the west came over the Hudson River bridge and was also stoned. Several Pinkertons opened fire, striking a woman in the leg and a small boy in the thigh. The excitement of the crowd was worked up to a fever pitch and was only held back by the efforts of the police and committees of the strikers. The mob had just settled down when another freight came through, and the Pinkertons again opened fire, this time hitting a small boy in the arm. Officer Dunn jumped on the train and tried to find the detective who fired the shot but was unsuccessful.

Over the course of the day, five Pinkertons were arrested for inciting violence. Robert Pinkerton, the head of the agency, asked for their release, but Chief Willard said that they were responsible for most of the violence that day. Captain Sheridan of the Third Precinct told a reporter: "It is true that a few women and children threw stones at the men on the freight trains, but I saw the Pinkerton men fire at the groups of people on the street who had nothing to do with it whatever and without provocation."

When news of the bloodshed was published the next day, condemnation came in from all parts of the country. The *Des Moines News* stated that "Pinkertonism is growing into an unmitigated evil—the regular civil authorities are or ought to be strong enough to preserve order without the interference of mercenary troops hired by corporations." The *Sioux City Times* noted, "The railroad men made a serious mistake the day they engaged Bob Pinkerton to protect property—the Pinkerton forces are made up of sluggers and bums and given firearms with instructions to use them in self-defense. It is a dangerous business to place firearms in the hands of undrilled men and turn them out to quell a disturbance."

Despite the Pinkerton debacle, the strike was doomed to failure when the Federation of Railway Employees refused to support the Albany local union. Within Albany itself there was disorganization, as the engineers and firemen also refused to join the brakemen, switchmen, yardmen and freight handlers, which made it easier for the New York Central to keep at least some trains running. The strike was officially ended at New York City on August 12; at Albany, it ended a week later. By August 25, all passenger and freight traffic had resumed former levels. Of the five thousand who went on strike, only one thousand or so were able to go back to work at their former positions, but even those lucky enough to have a job were forced to enter employment as "new" employees with no seniority or accumulated benefits.

Two weeks after the strike ended, five men were arrested for deliberately wrecking several trains to retaliate against the New York Central. Thomas Cain confessed that he and John Kiernan walked up the railroad tracks through Greenbush on August 29 with the intention of throwing a train off the track. Cain stood guard with a pistol, while Kiernan situated the ties so that the ends of several extended over the tops of the opposite rail. On September 4, Cain, Arthur Buett and Reed selected a switch in Rensselaer and jammed it halfway open with a fishplate. Two other strikers caused the *Montreal Express* to derail near Castleton. Miraculously, none of the wrecks caused any deaths.

The story grew more insidious when it was alleged that one of the heads of the union not only knew who committed the crimes but also aided them with money to escape. Kiernan and Cain visited Master Workman Lee at his home the following day. Lee told them that another striker had given their names to the authorities and that it would just be a matter of time before they were all arrested. He allegedly gave each of them thirty dollars and said to get out of town. The pair took a Central train to Utica, where they bought tickets for Ogdensburg, but Pinkerton detectives caught up with them and made the arrests.

# Labor Wars

Although the Great Strike of 1877 was considered to be a defeat for Knights of Labor leader Terrance V. Powderly (center), he went on to successfully strike against the Union Pacific and Jay Gould's Wabash Railroad. However, a series of defeats in the 1890s led to a steep decline in membership.

Despite the failure of most railroad strikes and declining union membership rolls, the Switchmen's Union at the Erie and the Lehigh Valley and Buffalo Creek Railroads based in Buffalo went on strike in 1892 to obtain a pay rate equal to "Chicago scale," which was slightly higher than the scale paid in New York. A week later, railroad switchmen of the New York Central, the West Shore and the Nickel Plate Railroads also went on strike with similar demands. Soon after the strike was called, mobs of men began derailing trains and, in some cases, setting them on fire, causing more than $100,000 in damages to railroad property. The strikers claimed that they were not complicit with such actions, but an investigation revealed that these activities had been discussed at a union meeting. When a group of deputy sheriffs was overwhelmed by the mobs, the state militia was called to respond. While guarding railroad buildings, the police and militia were attacked by a stone-throwing mob that could only be beaten back by the extensive use of clubs and bayonets, resulting in many casualties. The strike ended when an overwhelming force of state militia arrived that outnumbered the strikers by as many as eight to one. A determined effort to involve other brotherhoods in a sympathetic strike failed, and most of the strikers lost their jobs.

By the 1890s, the Knights of Labor was already experiencing a steep decline in membership, from a high of 700,000 in 1886 to just one-tenth of that a decade later. After several successful strikes, such as the Union Pacific Strike of 1884 and the Wabash Railroad Strike of 1885, there was a string of failures like the ones in New York State described here that cost tens of thousands of members their jobs. The "railroad brotherhoods," such as the Brotherhood of Locomotive Engineers and the order of Railway Conductors, greatly expanded their memberships as the Knights of Labor faded into history. These organizations were not nearly as radical as the Knights and generally worked amicably with railroad management. Their main goals involved negotiating workplace rules, establishing health and life insurance programs and enacting grievance procedures.

The violence and disruption of some of the strikes led Congress to pass the Arbitration Act of 1888, which created arbitration panels to investigate labor disputes and issue nonbinding awards. The act proved to be ineffective, so Congress passed the Erdman Act to make awards binding by federal law. Discrimination against union employees was outlawed, and both sides were required to maintain the status quo during arbitration for three months after an award was issued. The Railway Labor Act of 1926, which replaced strikes with federally enforced arbitration and mediation, effectively ended the labor wars that had lasted more than four decades.

# Timeline of Selected Events

October 26, 1825—The Erie Canal officially opens between Albany and Lake Erie.

September 24, 1831—New York's first railroad, the Mohawk and Hudson, is opened between Albany and Schenectady.

May 17, 1853—Ten railroads are merged into the New York Central.

May 19, 1853—Construction of the New York and Erie Railroad reaches its full length from Dunkirk to Jersey City.

September 1, 1854—Erastus Corning of the New York Central arranges a meeting of the country's four trunk lines at the St. Nicholas Hotel to set rates.

June 25, 1861—The New York and Erie is reorganized as the Erie Railway (first bankruptcy of a U.S. trunk line).

April 11, 1863—Vanderbilt assumes the presidency of the New York and Harlem Railroad.

August 24, 1863—Culmination of the first "Harlem corner" by Vanderbilt.

June 1, 1864—Vanderbilt corners the Harlem for the second time.

June 14, 1865—Vanderbilt assumes the presidency of the Hudson River Railroad.

December 12, 1866—A coup at the New York Central forces Vanderbilt off the board of directors.

January 18, 1867—Vanderbilt severs the rail connection between the New York Central and the Hudson River Railroads, causing a gridlock of freight in Albany.

# Timeline of Selected Events

October 8, 1867—Drew is removed from the Erie Railway board of directors but is reinstated the next day with Vanderbilt's support.

December 11, 1867—Vanderbilt assumes the presidency of the New York Central.

February 17, 1868—Drew talks the Erie Board of Directors into issuing $10 million in new bonds "for construction purposes," but they are immediately converted into stock.

February 29, 1868—Vanderbilt begins buying Erie shares and triggers the Great Erie War.

March 9, 1868—The Erie Ring dumps fifty thousand fictitious shares on the market to prevent Vanderbilt from cornering the stock.

March 10, 1868—The members of the Erie Ring flee to New Jersey when they are told that warrants were issued for their arrest.

April 25, 1868—An announcement is made that Vanderbilt and the Erie Ring reached a settlement, ending the Great Erie War.

December 19, 1868—Vanderbilt announces an 80 percent scrip dividend on the New York Central and is accused of "watering" the stock.

January 13, 1869—The Albany and Susquehanna Railroad is opened between Albany and Binghamton.

August 9, 1869—The fight at Belden Tunnel takes place during the Susquehanna War.

November 1, 1869—Vanderbilt merges the New York Central with the Hudson River Railroad.

February 24, 1870—The Delaware and Hudson Canal Company leases into perpetuity the Albany and Susquehanna, thus ending the Susquehanna War.

January 6, 1872—Jim Fisk is murdered by Edward Stokes.

March 11, 1872—At an Erie Board of Directors meeting, Jay Gould is removed from the executive leadership and subsequently resigns from the board.

January 4, 1877—Death of Cornelius Vanderbilt.

September 18, 1879—Death of Daniel Drew.

December 8, 1885—Death of William Vanderbilt.

December 2, 1892—Death of Jay Gould.

# Bibliography

*American Illustrated Magazine*. New York: Colver Publishing House, November 1905–April 1906.

*Appleton's Annual Cyclopedia and Register of Important Events of the Year 1877*. New York: D. Appleton and Company, 1890.

Bernstein, Peter. *Wedding of the Waters: The Erie Canal and the Making of a Great Nation*. New York: W.W. Norton and Company, 2005.

Commons, John. *History of Labour in the United States*. New York: Macmillan Company, 1918.

Dana, H.T. *Stray Poems and Early History of the Albany and Susquehanna Railroad*. York, PA: P. Anstadt and Sons, 1903.

Fleming, Robert. *Depraved Finance*. New York: Robert Fleming Publishing Company, 1904.

Flynn, John. *Men of Wealth*. New York: Simon and Schuster, 1941.

Gordon, John. *The Scarlet Woman of Wall Street: Jay Gould, Jim Fisk, Cornelius Vanderbilt, the Erie Railway Wars, and the Birth of Wall Street*. New York: Grove/Atlantic, 1990.

# Bibliography

Halstead, Murat, and J. Frank Beale. *Life of Jay Gould: How He Made His Millions*. New York: Edgewood Publishing Company, 1892.

Headley, J.T. *Pen and Pencil Sketches of the Great Riots*. New York: E.B. Treat and Company, 1882.

Hudson, James. *The Railways and the Republic*. New York: Harper and Brothers, 1886.

Hungerford, Edward. *Men and Iron: The History of the New York Central*. New York: Thomas Crowell Company, 1938.

———. *The Modern Railroad*. Chicago: A.C. McClurg and Company, 1911.

Kennedy, J.H., ed. *Magazine of Western History Illustrated*. Cleveland, Ohio, 1888.

Klein, Aaron. *The Men Who Built the Railroads*. New York: Gallery Books, 1986.

———. *The New York Central*. New York: Bonanza Books, 1985.

Livingston, John. *The Erie Railway: Its History and Management*. New York: John Palhemus, 1875.

Loree, L.F. *Railroad Freight Transportation*. New York: D. Appleton and Company, 1922.

McAlpine, R.W. *The Life and Times of Col. James Fisk, Jr*. New York: New York Book Company, 1879.

Moody, John. *The Railroad Builders*. New Haven: Yale University Press, 1921.

Morris, Charles. *The Tycoons: How Andrew Carnegie, John D. Rockefeller, Jay Gould, and J. P. Morgan Invented the American Supereconomy*. New York: Henry Holt and Company, 2005.

Moulton, Harold. *Waterways Versus Railways*. Boston and New York: Houghton Mifflin Company, 1912.

# BIBLIOGRAPHY

Munsell, J. *The Origin, Progress and Vicissitudes of the Mohawk and Hudson Rail Road*. Albany, NY: self-published, 1875.

*The Nation: A Weekly Journal*. E.L. Godkin and Company, New York, 1867.

*National Waterways: A Magazine of Transportation*. National Rivers and Harbors Congress, Washington, D.C., 1912.

Northrup, Henry. *Life and Achievements of Jay Gould, the Wizard of Wall Street*. Philadelphia, PA: S.M. Southard Publishing Company, 1892.

Poor, Henry. *History of the Railroads and Canals of the United States of America*. New York: John Schultz and Company, 1860.

Renehan, Edward. *Commodore: The Life of Cornelius Vanderbilt*. New York: Basic Books, 2007.

———. *Dark Genius of Wall Street: The Misunderstood Life of Jay Gould, King of the Robber Barons*. New York: Basic Books, 2005.

Ripley, William. *Railroad Rates and Regulations*. New York: Longmans, Green and Company, 1913.

*The Scrapbook*. New York: Frank A. Munsey Company, January–June 1908.

Shaw, Ronald. *Erie Water West: A History of the Erie Canal*. Lexington: University Press of Kentucky, 1990.

Sobel, Robert. *The Fallen Colossus*. Washington, D.C.: Beard Books, 2000.

Sowers, Don. *The Financial History of New York State*. New York: Columbia University Press, 1914.

Stebbins, Homer. *A Political History of the State of New York, 1865 to 1869*. New York: Columbia University, 1913.

Stedman, Edmund. *The New York Stock Exchange*. New York: Stock Exchange Historical Company, 1905.

# Bibliography

Stiles, T.J. *The First Tycoon: The Epic Life of Cornelius Vanderbilt*. New York: Vintage Books, 2009.

White, Bouck. *The Book of Daniel Drew*. New York: George H. Doran Company, 1910.

Whitford, Noble. *History of the Canal System of the State of New York*. Albany, NY: Brandow Printing Company, 1905.

Youngman, Anna. *The Economic Causes of Great Fortunes*. New York: Bankers Publishing Company, 1909.

Dozens of newspaper articles were also referenced, including the microfilm collections of the New York State Library, the Albany Public Library, the Schenectady Public Library, the Saratoga Springs Public Library and the Troy Public Library. Digital collections include the Library of Congress's "Chronicling America" project, the *Brooklyn Daily Eagle* news archive, the *New York Times* news archive and the "Old Fulton Postcards" newspaper archive project conducted by Thomas Tryniski.

# INDEX

**A**

Albany  24, 27, 47, 65, 96, 142
Albany and Susquehanna Railroad  96
Albany Regency  87
Arbitration Act of 1888  150

**B**

Baltimore and Ohio Railroad  49
Barnard, George  100, 116
Belmont, August  126
Bergen Tunnel  112
Binghamton  97, 105
Blackall, R.C.  104
blockade (Hudson River Railroad)  87
Boston, Hartford and Erie Railroad  123
Broadway franchise  66
Buffalo  24, 42, 134, 137

**C**

Champlain Canal  40
Civil War  8, 35, 131
Corning, Erastus  42, 43, 71, 80, 81, 121, 143
Corning (town of)  137

**D**

Delaware and Hudson Canal Company  109
Drew, Daniel  11, 69, 72, 83, 112, 114, 125

**E**

East Albany  76
Elkins Law  63
Erie Canal  25, 27, 35, 36, 40
Erie Railway  43, 49, 83, 97, 110, 134
Erie Ring  110, 119

**F**

Fargo, William  85
Featherstonhaugh, George  17, 27, 28
Fisk, Jim  15, 97, 102, 107, 115, 125
Fort Taylor  120

**G**

Gordon, Lord Gordon  127
Gould, Jay  13, 97, 115, 118, 121, 125, 127, 130
Grand Central Depot  94
Grand Trunk Railway  49, 51

# INDEX

Great Erie War  13, 14, 17, 47, 110, 120, 124, 128, 130, 152
Great Strike of 1877  132, 145

## H

Harlem corner  67, 69
Hornellsville  134
Hudson River  73
Hudson River Bridge  82
Hudson River Railroad  74, 81

## I

Interstate Commerce Commission  63

## J

Jerome, Leonard  71
Jersey City  119

## K

Keep, Henry  85
Knights of Labor  131, 146

## M

Manhattan  94, 119, 146
Manhattan elevated railroads  17
Mohawk and Hudson Railroad  27
Mohawk Valley  23, 35

## N

New York and Erie Railroad  30. *See* Erie Railway
New York and Harlem Railroad  64
New York Central  35, 42, 47, 49, 60, 75, 79, 81, 89, 132
New York Central and Hudson River Railroad  93
New York State Militia  136
New York State Supreme Court  19, 20, 57, 92, 101, 116, 135
Nickel Plate  53

## P

Pennsylvania Railroad  41, 60
Pinkerton Detective Agency  146
Pullman Car Company  56

## R

railroad pool  51
Ramsey, Joseph  97, 102, 107
Rensselaer and Saratoga Railroad  82
Richmond, Dean  85

## S

Saratoga and Hudson River Railroad  83
Schenectady  27
Schenectady and Troy Railroad  81
South Pennsylvania Railroad  62
Stewart, Alexander  65
stock watering  93
strike of 1890  145
Syracuse  144

## T

Taylor Hotel  119
Tobin, John  71, 75
Troy  81
Trunk Line Pool  52
Tweed, William "Boss"  70, 124

## U

Utica and Schenectady Railroad  31, 32

## V

Vanderbilt, Cornelius "Commodore"  9, 12, 47, 65, 67, 74, 87, 89, 91, 110, 116, 119, 123
Vanderbilt, William  51, 54, 62, 84, 142
Van Valkenburgh, John  102

## W

Wagner Palace Car Company  56
West Albany  142
West Shore Railroad  55, 58

# ABOUT THE AUTHOR

Timothy Starr was born in Danbury, Connecticut, and grew up in Hebron, New York. His first book was written in high school, a novel called *The Meatloaf Incident and Other Adventures* that is based on his experiences in a rural community. After receiving degrees in history, accounting and business administration, he moved to the historic county of Saratoga. Several prominent ruins around the town of Milton piqued his interest and led to the writing of his first nonfiction books, titled *Lost Railroads of the Kaydeross Valley* and *Lost Industries of the Kaydeross Valley*. When he discovered that several important innovations were developed locally, other projects unfolded relating to the inventions of Ballston Spa, Saratoga County and the Capital District. A lifelong interest in railroading led to three books that describe the history of railroads within the Capital Region of New York.

For most of his career, Tim has been involved in accounting and finance in the nonprofit industry. He has contributed chapters to several local history books and is frequently seen in various print publications. He is a member of the Bridge Line Historical Society and the New York Central System Historical Society, and he volunteers as the treasurer of the Saratoga County Historical Society. He lives in Rock City Falls with his wife, Alison, and daughter, Morgan.

OTHER BOOKS BY THE AUTHOR

*Early Railroads of New York's Capital District*
*The Golden Age of Railroads in New York's Capital District*
*Railroading in New York's Capital District: Hot Off the Presses!*
*Lost Railroads of the Kaydeross Valley*
*The Ballston Terminal Railroad and Its Successors*
*Lost Industries of Saratoga County*
*Lost Industries of the Kaydeross Valley*
*Great Inventors of New York's Capital District*
*Invented in Saratoga County*
*Invented in Ballston Spa*
*The Paper Bag King: A Biography of George West*
*Isaiah Blood: Scythe and Axe Maker of Ballston Spa, New York*
*Leading Industrial Pursuits of Ballston Spa, Glens Falls, Sandy Hill & Fort Edward*